MW00977359

IMAGES
of Rail

METROPOLITAN NEW YORK'S
THIRD AVENUE
RAILWAY SYSTEM

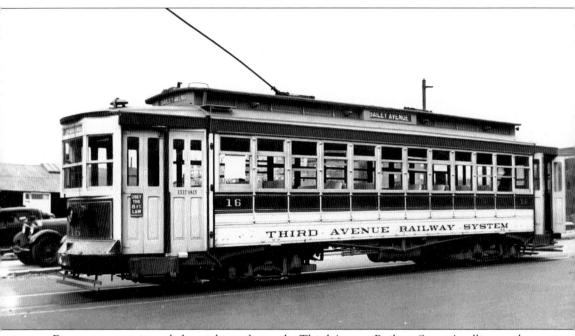

For many years prior to lightweight steel cars, the Third Avenue Railway System's rolling stock was characterized by the Brill convertible car. In 1909 and 1911, 200 straight-side cars like No. 16 were built. They were so sturdy that they remained in service until 1947 and 1948. This view of No. 16 shows the company's standard color scheme of red and cream and lettering displaying the system's name. To reduce cost, the lettering was replaced by a small circular emblem.

IMAGES
of Rail

METROPOLITAN NEW YORK'S THIRD AVENUE RAILWAY SYSTEM

Charles L. Ballard

ARCADIA

Copyright 2005 by Charles L. Ballard and Donald J. Engel
ISBN 0-7385-3810-8

Published by Arcadia Publishing
Charleston SC, Chicago IL, Portsmouth NH, San Francisco CA

Printed in Great Britain

Library of Congress Catalog Card Number: 2005926987

For all general information contact Arcadia Publishing at:
Telephone 843-853-2070
Fax 843-853-0044
E-mail sales@arcadiapublishing.com
For customer service and orders:
Toll-Free 1-888-313-2665

Visit us on the Internet at http://www.arcadiapublishing.com

To my wife, Bobbi Marie Ballard
To Don Engel for his assistance as co-editor
To George Hanson for putting me in contact with Arcadia Publishing
Thanks to all!

Shown here is the Third Avenue
Railway System's circular emblem.

CONTENTS

Introduction 7

1. Manhattan Lines 9

2. Bronx Lines 39

3. The Yonkers Railroad 71

4. The Westchester Electric Railroad 91

5. Car Barns and Repair Shops 105

6. Work and Service Cars 111

7. Car Retirement and Scrapping 119

8. The Queensboro Bridge Railway 123

Appendix 128

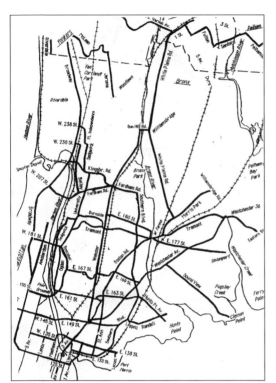

Shown here is the Third Avenue Railway System street car lines in the Bronx and northern Manhattan as of 1941.

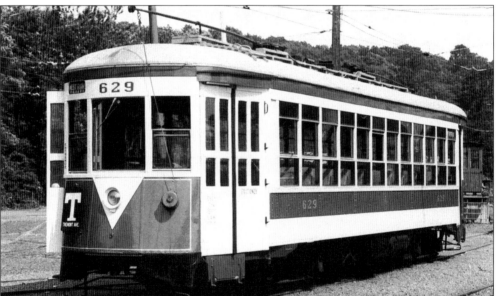

In 1949, forty-two of the newest cars built in 1939 were sent to Vienna, Austria, as part of the Marshall Plan to aid war-ravaged Europe. With few modifications, they operated in Vienna until the 1960s, when they were gradually retired. Through the cooperation of the city of Vienna, several former Third Avenue cars have been preserved in railway museums. Car No. 629 was contributed to the Branford Electric Railway Museum in East Haven, Connecticut, through the cooperation of the Austrian government. It has been preserved there in operating condition and has been restored to its appearance when operated in New York.

INTRODUCTION

City hall to Yonkers and New Rochelle! New York's extensive Third Avenue Railway System operated all the streetcar lines in Manhattan, the Bronx, and adjacent Westchester County from 1940 to 1952. From the extreme southern terminus of its Third Avenue route at New York's city hall (Park Row), its service extended to southern Westchester County. This extensive system transported nearly one million passengers each day.

Urban street railways powered by horses rapidly replaced inefficient horse-drawn omnibuses after 1850. Responding to the rapid growth of New York's population, the Third Avenue Railroad Company obtained its first franchise in 1852 to construct a street railway on Chatham Street, the Bowery, and Third Avenue from Ann Street to the Harlem River. Operation commenced in July 1853. Despite later competition from the Third Avenue elevated railroad, constructed in 1878, the company was financially successful. From 1884 to 1886, it extended its street railway west on 125th Street and north on Amsterdam Avenue, adopting the expensive cable railway system. After extensive litigation, the Third Avenue line was also converted to cable operation in 1893 and 1894.

The company began an aggressive policy of expansion from 1895 to 1898. In 1895, it obtained a franchise to extend its street railway on Broadway from 162nd Street north to the city limit at 262nd Street. In 1898, it added to its existing routes by acquiring street railway lines in Manhattan, the Bronx, and southern Westchester County through the purchase of the capital stock of the Union Railway Company, the Westchester Electric Railroad Company, the Yonkers Railroad Company, and the 42nd Street, Manhattanville, and St. Nicholas Avenue Railroad Company. A final and major addition—completing the company's Bronx monopoly—was the purchase in 1912 of the New York City Interborough Railway. Swift growth of trolley, or electric railway, lines had followed the successful installation of an electric street railway by Frank J. Sprague in Richmond, Virginia, in 1888. Sprague's system required an overhead trolley wire, but the electrification of Manhattan's streetcar routes was prevented because the city of New York steadfastly prohibited overhead wires on the streets of Manhattan. However, in 1895, the General Electric Company developed a successful alternative: the underground conduit railway system. The company then proceeded in 1899–1900 to electrify its Manhattan routes with the conduit system replacing the cable railway.

The financial consequence of corporate acquisitions, construction of cable lines, and their subsequent conversion to electricity exhausted funds and forced the Third Avenue Railroad Company into bankruptcy in January 1900. Its Manhattan competitor, the Metropolitan Street Railway, took advantage of Third Avenue's insolvency by leasing its railway property for a term of

999 years. Metropolitan's own bankruptcy in 1908 canceled the lease, and Third Avenue again became independent but also insolvent, and went back into receivership until 1911. The receiver improved the property, including the purchase of 515 new cars between 1908 and 1911.

In December 1911, the company was reorganized as the Third Avenue Railway Company. During the next 20 years, it prospered as the population in its service area increased. Service and route adjustments were made as rapid transit lines were extended in the Bronx. The company was competently managed and its property well maintained. The cars acquired by the receiver plus 100 cars purchased in 1916 and 1924 comprised most of the company's rolling stock. However, by 1930, Third Avenue's rolling stock was technologically and operationally obsolete, and the company was confronted with the formidable task of total equipment replacement. Political control of fares by the city of New York impaired the company's financial resources, which required that new cars be obtained with the lowest possible investment. The management resolved to cope with this problem through a unique program it devised by purchasing 61 used cars and constructing 600 lightweight steel cars of its own design. The construction of new cars commenced in 1934, and by 1939, some 336 cars had been completed in its large, well-equipped shop at East 65th Street and Third Avenue. In this period, the company was the second largest streetcar builder in the country.

During the building program, F. H. LaGuardia was elected mayor of New York. He had an open hostility to streetcars and wanted them banished from city streets. Third Avenue's red and cream streetcars were quite visible and became the object of his intransigent removal campaign. Threatening not to renew valuable and important bus franchises in the Bronx, LaGuardia coerced the company in August 1939 to agree to replace its streetcars with motor buses. Consequently, the car construction program was halted pending the conversion to bus operation. World War II intervened in 1941, halting the program per order of the United States Office of Defense Transportation. With the war over, in November 1946, the bus conversion program commenced, and by May 1947, all Manhattan car lines were now operated by motor buses. Immediate bus conversion was not required in the Bronx, but new management in 1947 embarked on an accelerated replacement of streetcars in that borough as well, completing the change in August 1948. The cost of this hasty and ill-considered bus conversion program created the anticlimax of bankruptcy in June 1948. Streetcar operation in Westchester continued until the abandonment of the New Rochelle–Pelham–Mount Vernon Subway lines in December 1950. The Yonkers Railroad streetcars continued to operate until November 1952.

One

MANHATTAN LINES

The center of metropolitan New York is densely populated Manhattan Island, where the Third Avenue Railway operated seven important streetcar lines on major thoroughfares, especially in northern or upper Manhattan. They included the original Third Avenue line, Forty-second Street, Broadway north of Forty-second Street, Fifty-ninth Street, 125th Street, Tenth Avenue, and Amsterdam Avenue. All these routes used the unique, complex, and costly underground conduit system instead of overhead trolley wire to supply electricity. Only the Washington, D.C., streetcar system also used this unique conduit system of power supply. Heavy passenger traffic on these routes required about 250 cars to provide the necessary frequent service. Many of the photographs of the Manhattan lines outside of the commercial districts clearly show the incredible density of Manhattan's population. All of Manhattan's streetcar lines were identified by letters displayed on the front of the cars except for the Tenth Avenue and Broadway–145th Street routes.

In this northward view on Park Row, car No. 106 is at the southern terminus of the long Third and Amsterdam Avenues line at Park Row and Broadway, the former site of the main post office (demolished in the 1930s, becoming City Hall Park). To the left of the car is New York's famous historic city hall; to the right is the Municipal Building and the southern terminus of the Third Avenue elevated railway. This was Third Avenue's longest car line, extending almost the entire north-south length of Manhattan from city hall to 190th Street and Amsterdam Avenue, a distance of approximately 12 miles. Out of view to the right of the "El" terminal is the Manhattan entrance to the famous Brooklyn Bridge.

The original southern terminus of the Third and Amsterdam Avenues line was a loop adjacent to the site of the former post office at Park Row and Broadway. The loop was removed in favor of the stub-end terminal shown in the previous image.

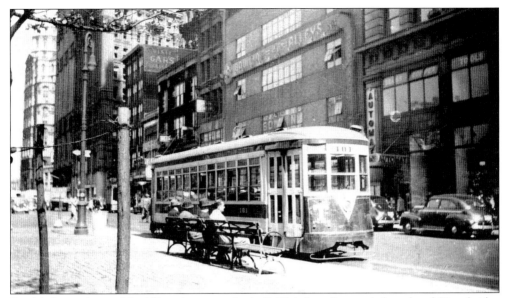

Steel lightweight car No. 101 is shown at city hall. This long line and the related Kingsbridge route required about 100 cars to provide the scheduled service. The Third Avenue Railway commenced an ambitious car-building program in 1934 to replace obsolete wooden equipment with modern steel. The first produced in this project were 100 cars numbered 101 to 200.

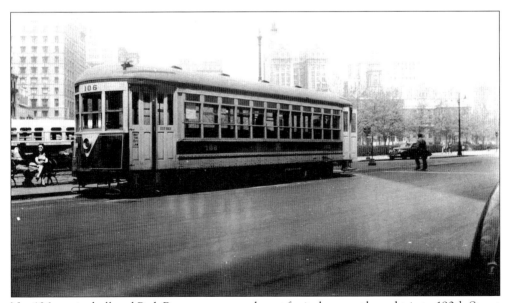

No. 106, at city hall and Park Row, prepares to depart for its long northward trip to 190th Street via Third Avenue, 125th Street, and Amsterdam Avenue. For the entire distance from city hall to 125th Street, the cars operated under the Third Avenue elevated railway line.

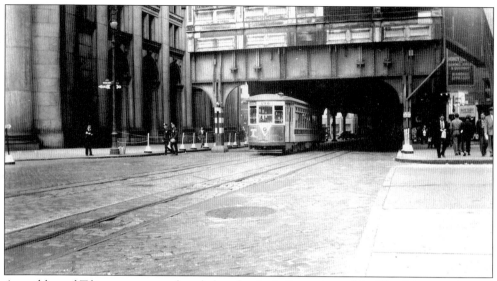

A southbound T-line car emerges from below the city hall terminus of the Third Avenue elevated railway. It is but a short distance to the end of the line at Park Row and Broadway.

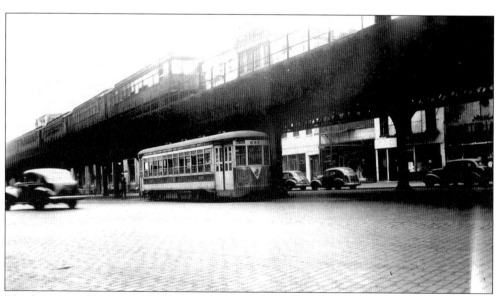

Third Avenue car No. 627 is at East Sixth Street and Third Avenue, Cooper Square. This is the location of Cooper Union, a four-year tuition-free engineering college established in 1859 by Peter Cooper. Overhead is the Third Avenue elevated railway.

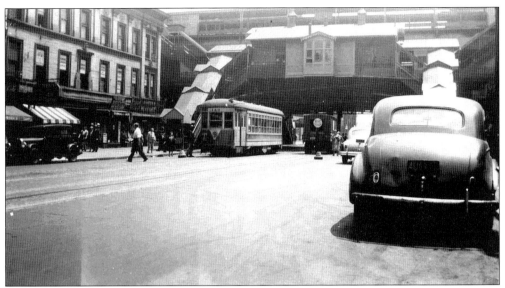

After traveling north from city hall on Third Avenue, car No. 140 has turned onto 125th Street. In the background is the 125th Street two-level station of the Third Avenue elevated railway.

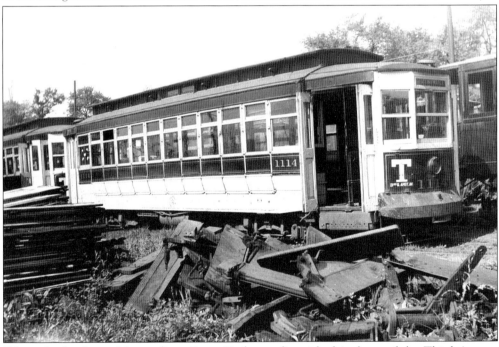

When the bankrupt Metropolitan Street Railway relinquished its lease of the Third Avenue Railroad Company in 1908, Third Avenue had to replace hundreds of obsolete streetcars with new cars. In this re-equipment program, the system acquired 295 curved-side convertible cars like No. 1114 from the J. G. Brill Company of Philadelphia in 1908. The merit of the design was that it provided a car that could be enclosed in the cold months and open in the hot summer, eliminating a duplicate set of cars for summer use. By 1930, these had become obsolete as well, and the company commenced replacement by building modern steel cars in its Manhattan shop. As the convertible cars and others were scrapped, usable parts were salvaged for re-use in new cars.

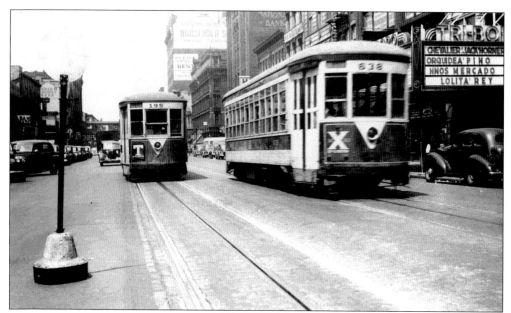

Looking west on 125th Street from Third Avenue, this view shows southbound No. 195 on the Third and Amsterdam Avenues line, while car No. 638 covers a westbound 125th Street crosstown trip. The underground conduit slot rails are clearly visible; the "plow," or current collector, on a car extended through the slot to collect electricity from the power rails in the conduit.

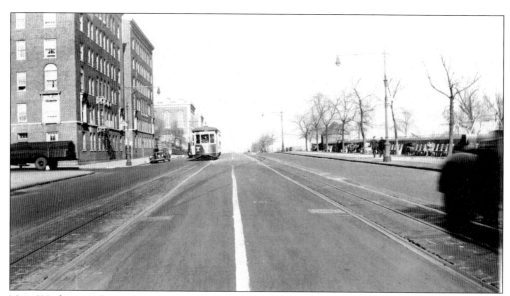

No. 639 departs from the north end of the Third and Amsterdam Avenues line near 190th Street and Amsterdam Avenue, also known as Fort George.

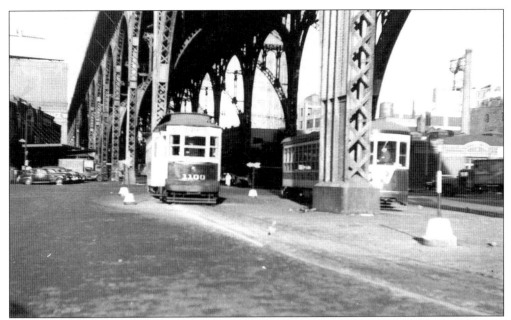

Shown here is car No. 1100 and a 600-series car at the West 125th Street double-track loop at the Fort Lee (New Jersey) Ferry terminal. Overhead is the Riverside Drive viaduct. Both the 125th Street Crosstown and Tenth Avenue lines terminated here. The convertible car is on the crosstown line, while the Tenth Avenue car is on the adjacent loop track.

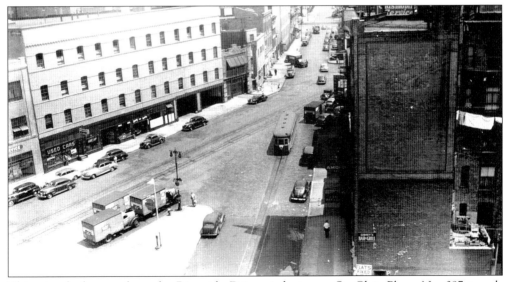

This view looks east from the Riverside Drive viaduct over St. Clair Place. No. 397 travels eastbound from the Fort Lee Ferry terminal on the 125th Street Crosstown route.

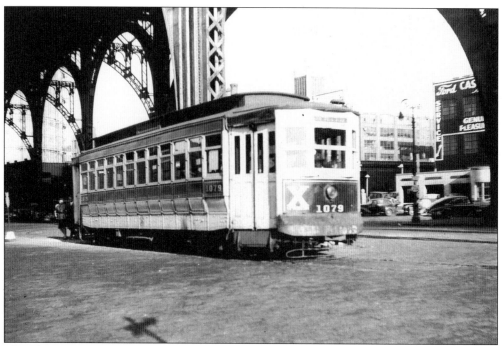

This close-up view displays curved-side convertible car No. 1079, with its side panels affixed, at the West 125th Street loop terminus. All Third Avenue's crosstown lines except one displayed the route sign "X."

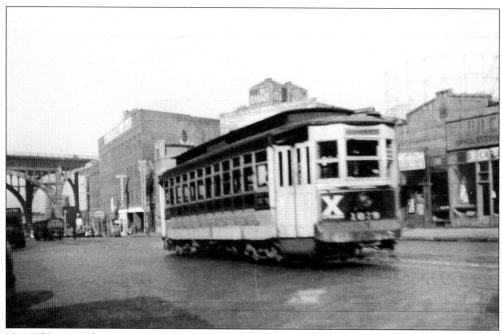

No. 1079 proceeds east on 125th Street immediately west of Broadway. In the background is the Riverside Drive viaduct.

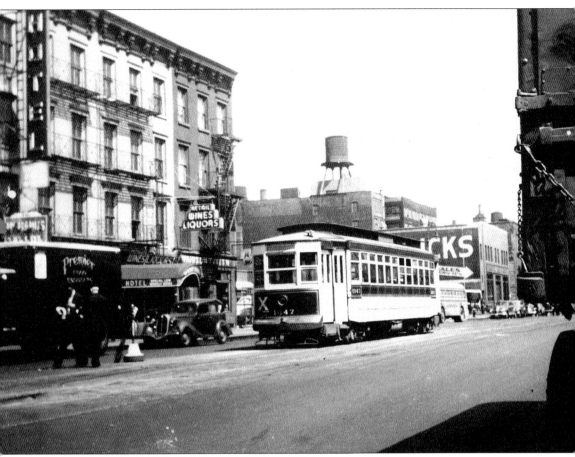

Weekday service on this important route was provided by older wooden convertible cars because no steel cars were available. In this ordinary urban view of West Forty-second Street between Eleventh and Twelfth Avenues, No. 1047 proceeds west to Twelfth Avenue and the West Shore Railroad (Weehawken) Ferry terminal.

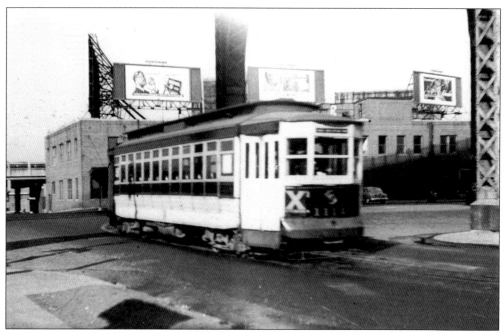

Crosstown car No. 1114 is eastbound, departing from the Twelfth Avenue loop track onto St. Clair Place, en route to 125th Street.

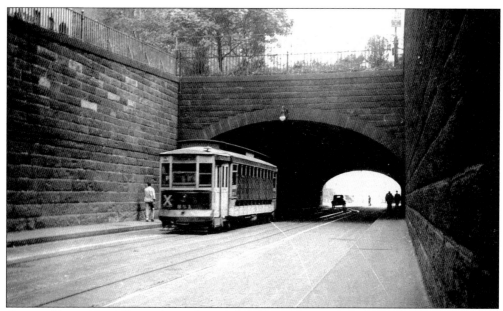

Convertible car No. 851 travels westbound from its First Avenue and East Forty-second Street terminal. The cold-weather panels have been replaced with screens for summer operation.

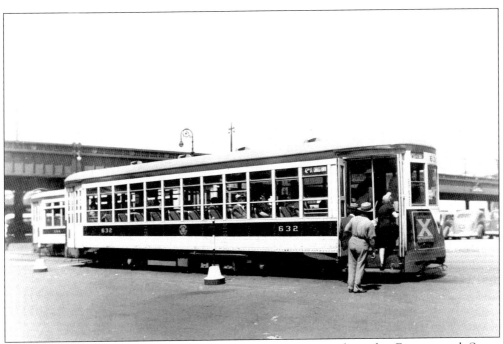

On Sundays and holidays, new 600-series cars were assigned to the Forty-second Street Crosstown line. Car no. 632 is boarding passengers at the Twelfth Avenue West Shore Railroad (Weehawken) Ferry terminal. Alongside is a 100-series car on the Tenth Avenue route.

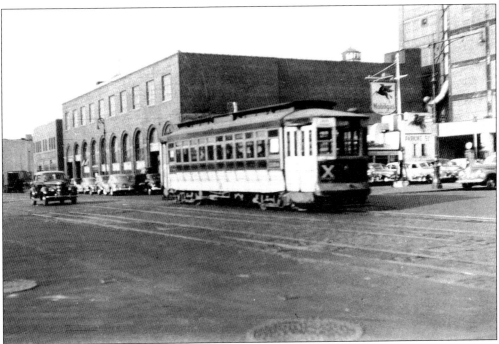

West Forty-second Street car No. 1054 nears its western terminus. The extra (third) track remains from the time when New York Railway's Thirty-fourth Street Crosstown car line also operated to the West Shore Railroad Ferry.

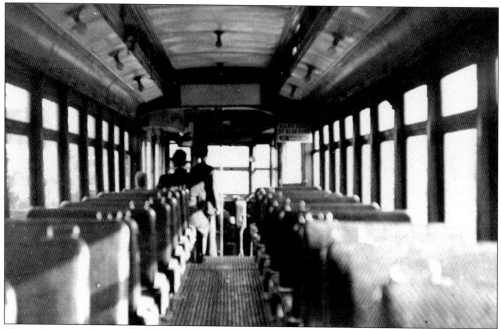

Shown here is the standard interior of the Third Avenue Railway System's convertible cars. Note the Johnson Fare Register on the front platform. The reversible seats were covered with rattan, a natural material widely used for streetcar seating.

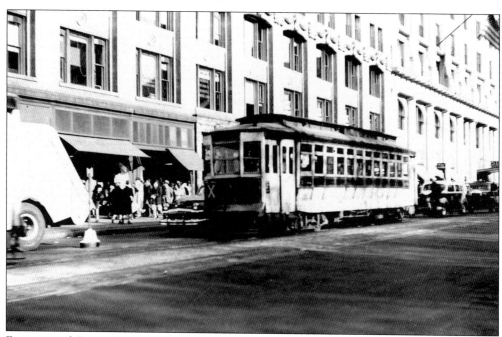

Forty-second Street Crosstown car No. 1104 rests at the mid-block car stop midway between Fifth and Sixth Avenues, opposite Bryant Park.

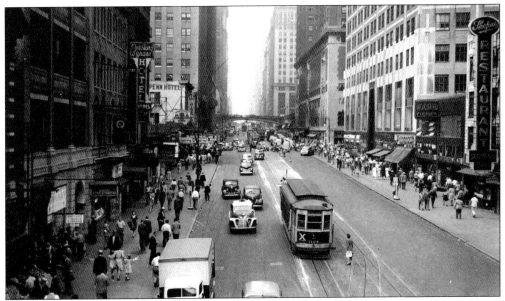

In this westward view of Forty-second Street from Third Avenue, car No. 1104 travels eastbound to the First Avenue terminus. The overpass in the background carries Park Avenue over Forty-second Street at Grand Central Terminal. Broadway and other Crosstown cars appear in the background.

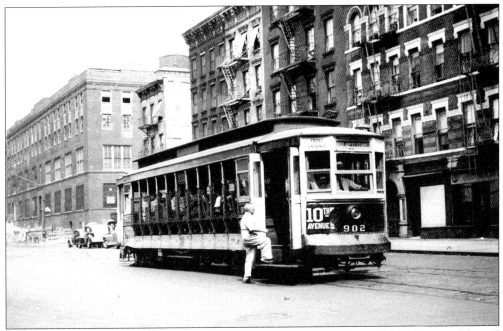

Unlike other lines, the Tenth Avenue line had no route letter. Here, car No. 902 is southbound at Tenth Avenue and Fifty-fourth Street. It is equipped with screens for summer operation. This section of New York is typical of Manhattan's West Side, incorporating both residential and commercial buildings.

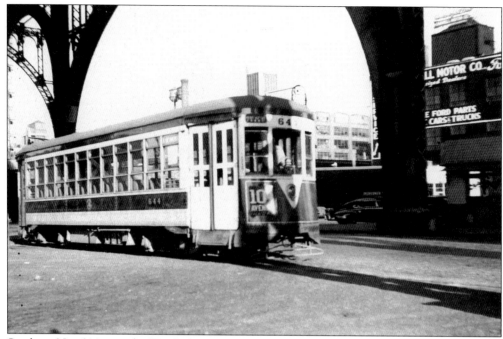

Steel car No. 644 provides Tenth Avenue service on this day instead of a wooden convertible car. It awaits departure from the route's northern terminus at West 125th Street and Twelfth Avenue, the Fort Lee Ferry landing.

Tenth Avenue cars operated on Broadway north of Seventy-second Street to 125th Street. In this view, car No. 1012 is at 117th Street and Broadway. In the background is Barnard College of Columbia University, and to the right is the spire of Riverside Church.

Car No. 999 is southbound on Broadway at Columbia University approaching the 116th Street IRT subway station. Broadway from Fifty-ninth Street to 125th street is a divided roadway under which the original IRT subway line operates.

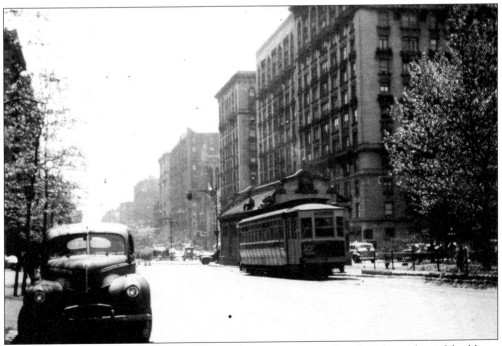

This is a typical uptown Broadway scene. The major street is lined with residential buildings and neighborhood stores. Tenth Avenue car No. 999 proceeds north between 116th and 117th Streets. Behind the car is the 116th Street IRT subway station.

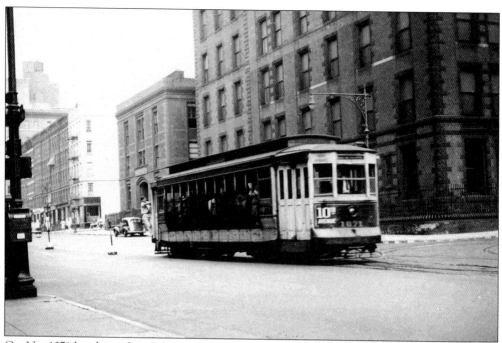

Car No. 1071 heads south at Fifty-ninth Street toward Forty-second and its terminus at the West Shore Railroad (Weehawken) Ferry.

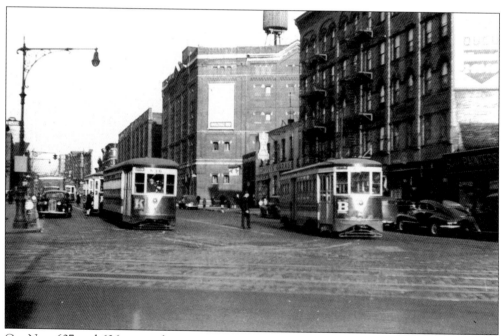

Car Nos. 607 and 636 are at the intersection of 125th Street and Amsterdam Avenue, a busy Manhattan streetcar junction served by three routes: Third and Amsterdam, Kingsbridge, and Broadway. The Broadway car travels north to its terminus at 129th Street, while the Kingsbridge car waits to proceed east on 125th Street.

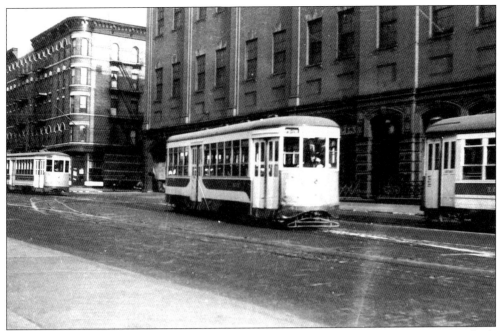

Shown here is car No. 579. The intersection of 129th Street and Amsterdam Avenue was both the north end of the Broadway line and the site of a multi-level car house serving the Broadway line. Streetcars stored in this barn were moved from street level to upper floors on large car elevators; the high cost of land in Manhattan made this type of building necessary.

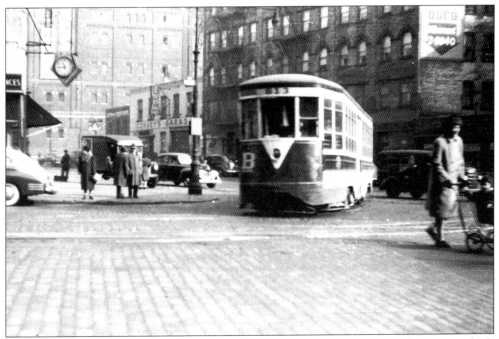

Broadway car No. 613 turns west from Amsterdam Avenue onto 125th Street. The company built 75 cars in 1937 and 1938 with a front entrance and a center exit especially for the Broadway line.

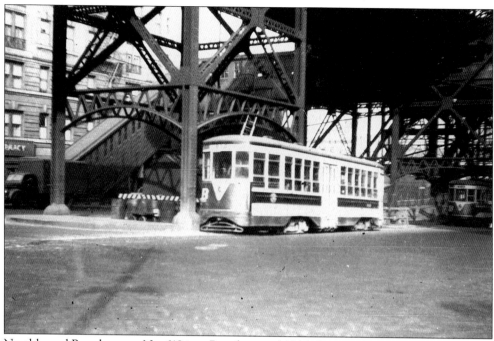

Northbound Broadway car No. 618 is at Broadway and 124th Street. The adjacent steel elevated railway structure carries the Broadway IRT subway across Manhattan Valley in the vicinity of West 125th Street.

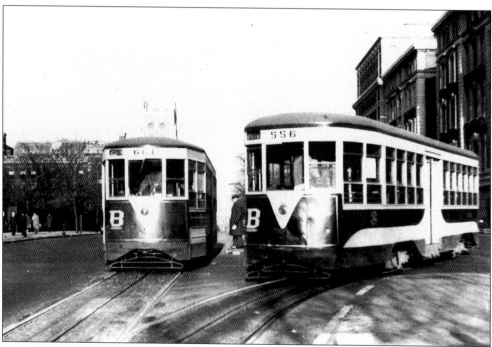

Broadway and 117th Street was the location of a northern short-turn terminus of some runs on the Broadway line. A supervisor was stationed here to maintain proper headway for southbound Broadway cars. This location is adjacent to the campus of Columbia University, seen in the background.

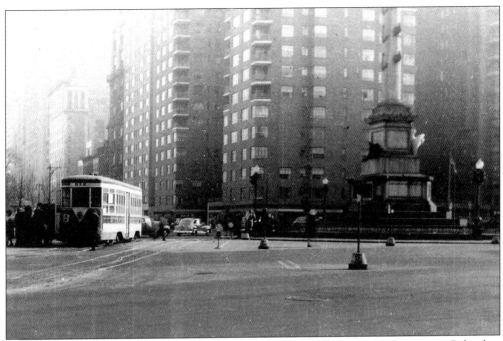

The intersection of Broadway, Fifty-ninth Street, and Eighth Avenue is known as Columbus Circle and includes a monument to Christopher Columbus, seen at the right. Here, the Broadway line crossed Third Avenue's Fifty-ninth Street Crosstown line.

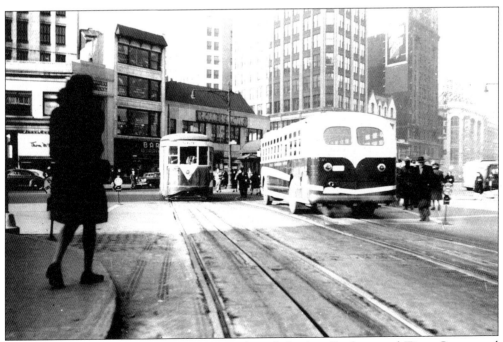

Oncoming Broadway car No. 569 moves south at Columbus Circle toward Times Square and Forty-second Street.

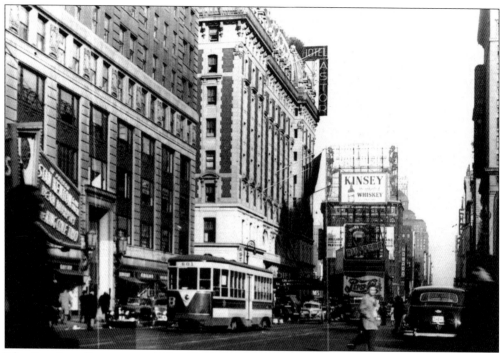

The Broadway line traversed New York's famous Times Square north of Forty-second Street. Here, No. 601 is between Forty-fourth and Forty-fifth Streets as it proceeds south to Forty-second and then east. In the rear view is the venerable Hotel Astor and the typical Times Square advertising billboards; to the left is the Paramount Theater. Times Square is considered to be the center of New York.

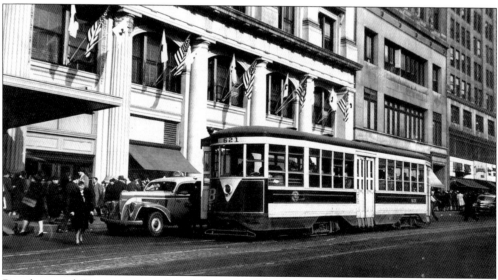

Broadway and Crosstown cars shared Forty-second Street from First Avenue to Times Square. The long length of the blocks on Manhattan's crosstown streets made mid-block car stops desirable. Here, northbound Broadway car No. 621 pauses for passengers between Fifth and Sixth Avenues on Forty-second Street opposite Bryant Park.

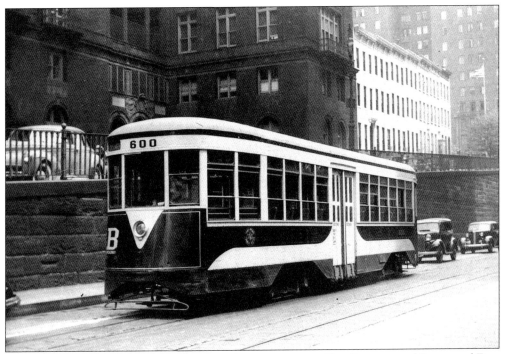

Broadway car No. 600 departs the line's southern terminus at East Forty-second Street and First Avenue. No. 600 was the last car of a group of 50 all-aluminum cars produced by the company in its East Sixty-fifth Street shop in 1938—the largest single order of all-aluminum streetcars built in the United States.

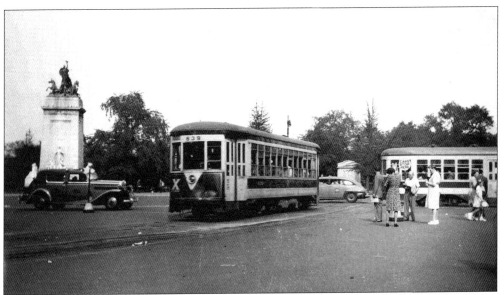

The Fifty-ninth Street Crosstown and Broadway routes intersected at Columbus Circle adjacent to the Columbus monument. Crosstown car No. 639 proceeds west, while Broadway car No. 551 waits to cross the Fifty-ninth Street tracks. The base of the Columbus monument is on the left, and in the background is the southwest corner of Central Park.

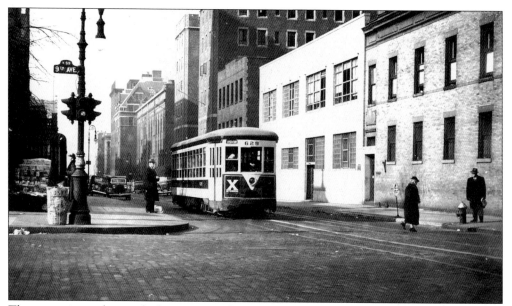

The street sign indicates the location as Fifty-ninth Street and Ninth Avenue. No. 629 was one of 20 newly built cars assigned to this line in 1939. It was also one of 42 Third Avenue cars sent to Vienna, Austria, in 1949 to replace war-damaged equipment.

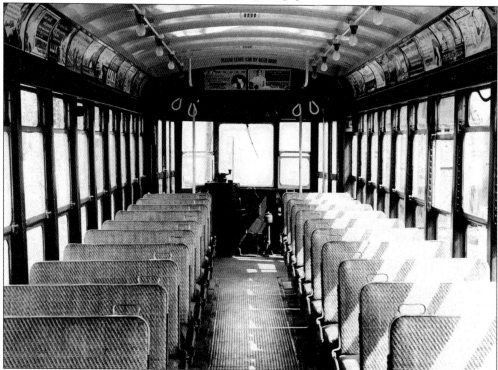

This is an interior view of Third Avenue's standard steel lightweight streetcar. The seating retained the sturdy rattan covering used in its convertible cars. The bare-bulb lighting indicates the extent of the effort to reduce construction costs. Quiet in operation, these cars had good riding quality.

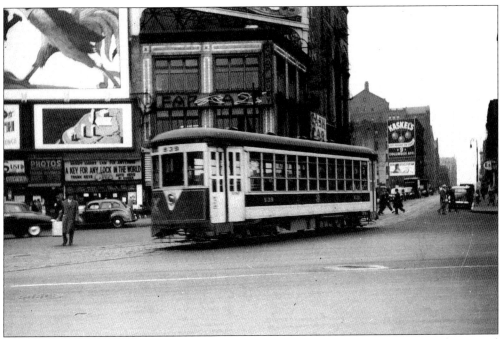

Westbound at Broadway is Fifty-ninth Street Crosstown car No. 639. The background is typical of Midtown Manhattan.

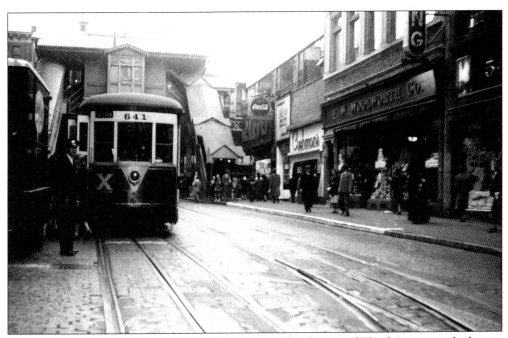

Car No. 641 appears here at Fifty-ninth Street immediately west of Third Avenue and adjacent to Bloomingdale's department store. For some runs, this was the eastern terminus.

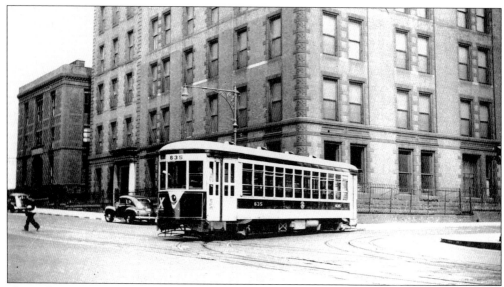

Shown here is car No. 635. On the West Side, Fifty-ninth Street Crosstown cars turned south onto Tenth Avenue and traveled to the end of the line at Fifty-fourth Street.

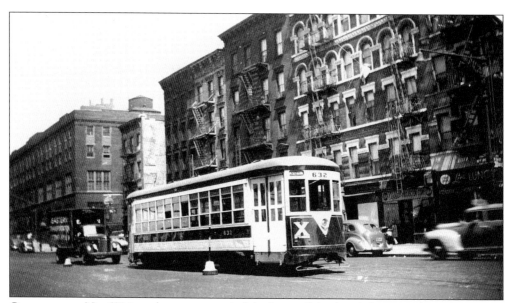

Crosstown car No. 632 is at the western end of the line at Fifty-fourth Street and Tenth Avenue, which was also the site of the Fifty-fourth Street depot.

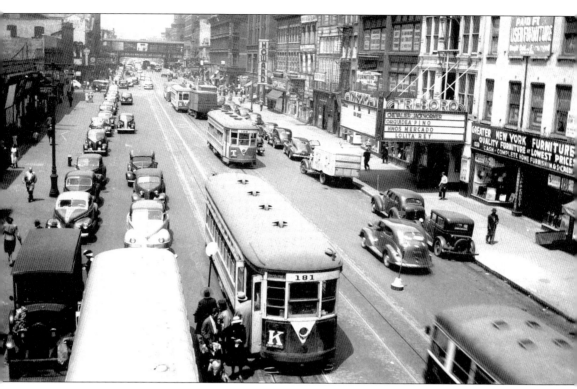

This view is looking west on 125th, the major Harlem crosstown street, from the Third Avenue elevated railway. Kingsbridge and Third Avenue cars operated on the same tracks on 125th Street and Amsterdam Avenue to 167th Street. In the background is the 125th Street station of the former New York Central Railroad, now the Metro-North Railroad.

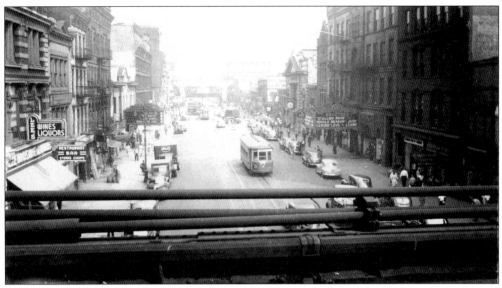

Looking west on 125th Street, from the 135th Street Metro North Station, the outbound Kingsbridge line car can be seen in the distance.

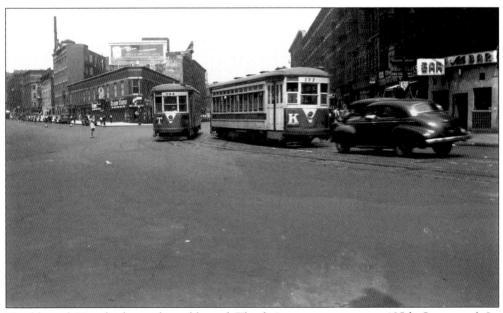

Northbound Kingsbridge and southbound Third Avenue cars pass at 125th Street and St. Nicholas Avenue.

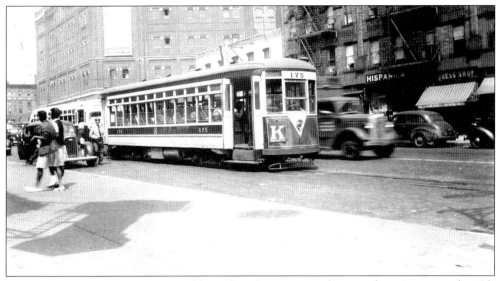

Kingsbridge car No. 175 travels southbound at the junction of Amsterdam Avenue and 125th Street prior to turning onto 125th. The high density of population in northern Manhattan provided heavy patronage on both T and K routes, which required short headways between cars.

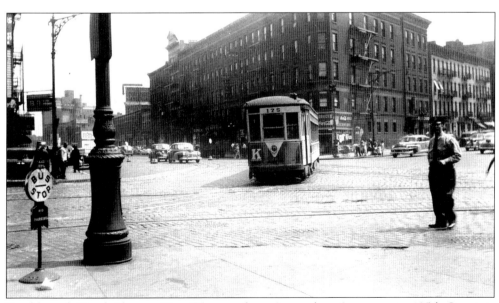

Southbound Kingsbridge car No. 175 turns from Amsterdam Avenue onto 125th Street to terminate its trip at Third Avenue.

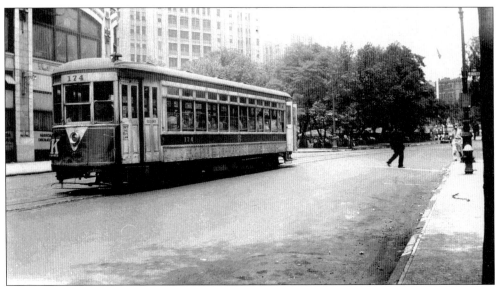

Kingsbridge car No. 174 is pictured on St. Nicholas Avenue at 166th Street in the spring of 1947.

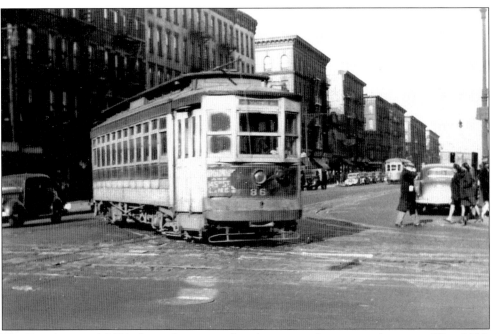

The Broadway and 145th Street line was a franchise route that operated west on West 145th Street to Broadway and then north on Broadway to 181st Street. It duplicated service provided by the 149th Street Crosstown and Kingsbridge lines. When the system converted to motor buses, this line was discontinued. Here, No. 86 turns north onto Amsterdam Avenue from 145th Street. This whole route was on conduit trackage but for a short distance on West 145th Street to a crossover that had trolley wire, hence the trolley poles on the cars.

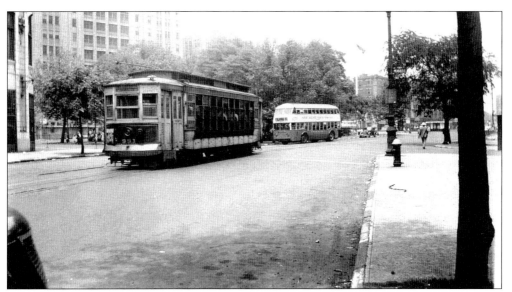

Convertible car No. 991 is fitted with screens for summer operation. The location is St. Nicholas Avenue at 166th Street.

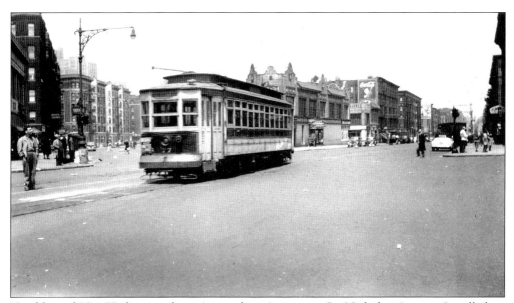

Northbound No. 77 diverges from Amsterdam Avenue to St. Nicholas Avenue. It will then operate on Kingsbridge line tracks to 181st Street. The car has been converted to winter service by replacing the screens with panels.

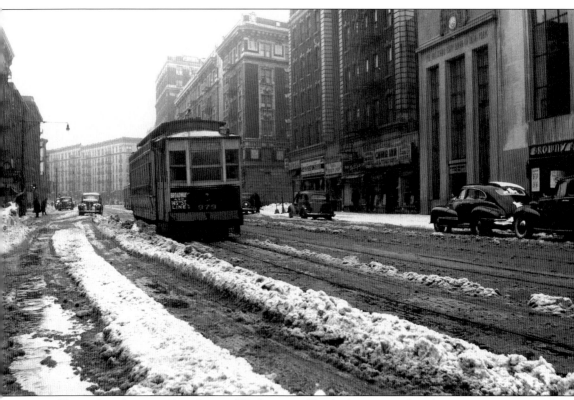

Upper Broadway at 181st Street (Washington Heights) is covered with a winter mixture of snow and slush. No. 979 reverses direction to return to its southern terminus on 145th Street. Broadway is lined with typical New York apartment buildings.

Two

BRONX LINES

The only portion of New York City on the mainland is the county and borough of the Bronx. It is separated from Manhattan by the Harlem River and from Long Island by the East River, Long Island Sound, and is bounded on the north by Westchester County. Mostly residential with some industry in the southeast, the Bronx had the Third Avenue Railway System's largest and densest network of streetcar lines and constituted over 40 percent of the entire railway operation. There were many major crosstown and north-south car lines, several of which stretched across the Harlem River to terminals on West 155th and 181st Streets in Uptown Manhattan, where passengers could transfer to the Interborough Rapid Transit (IRT) subway. Acquisition in 1898 of the Union Railway Company and later in 1912 of the New York City Interborough Railway created Third Avenue's monopoly of Bronx streetcar lines. Two car houses served to store and service the Bronx cars: Kingsbridge Depot on Broadway near the Harlem River and West Farms Depot on Boston Road. Two routes in bordering Westchester County connected those lines with the Bronx system: one each from Yonkers and Mount Vernon.

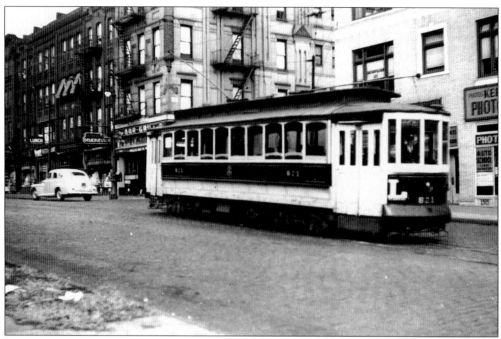

Car No. 821 is eastbound on the 138th Street Crosstown line at Cypress Avenue. The car should carry the letter X for the crosstown route sign, but incorrectly carries the letter L.

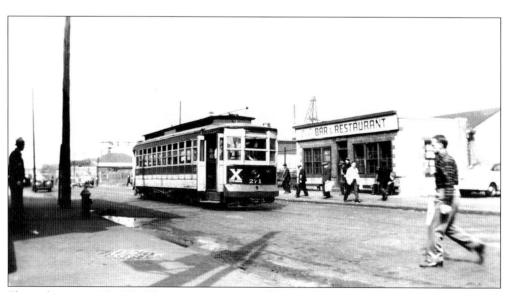

Shown here is car No. 271. The eastern terminus of the 138th Street route was at its intersection with Locust Avenue.

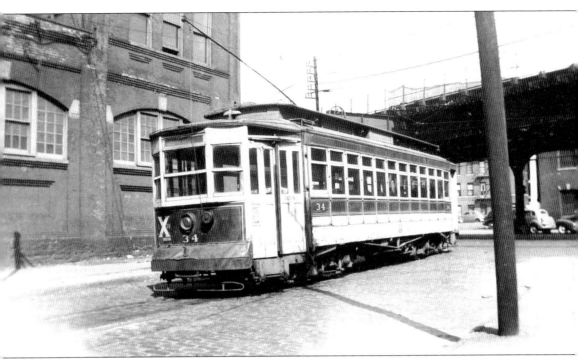

Convertible car No. 34 departs West Farms Depot to go into service on the 138th Street Crosstown line.

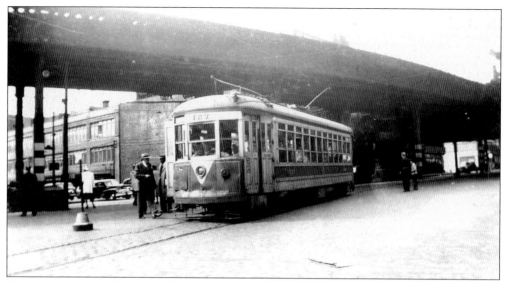

Passengers board steel car No. 127 at the north end of the St. Ann's Avenue line at 161st Street. Above is the Bronx extension of the IRT East Side subway line. Transferred from Manhattan in 1947, the steel cars replaced obsolete wooden cars.

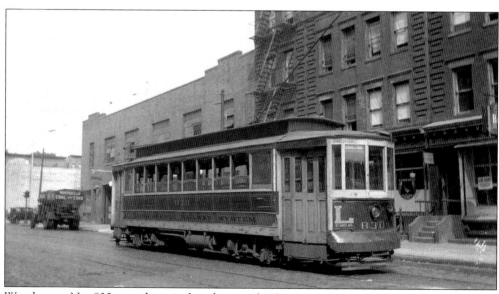

Wooden car No. 830 served out its last days on the St. Ann's Avenue line. It is shown here on 133rd Street near the Harlem River. This car escaped scrapping and, once retired, was donated to the Branford (Connecticut) Electric Railway Museum in 1947 for preservation.

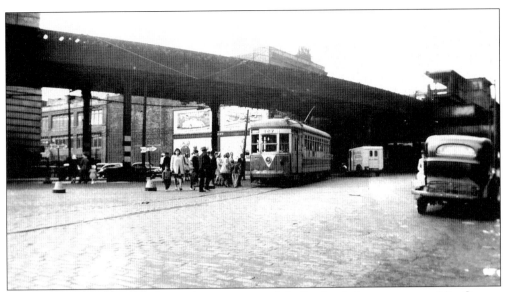

Passengers board No. 127 at the northern terminus of the St. Ann's Avenue route at 161st Street.

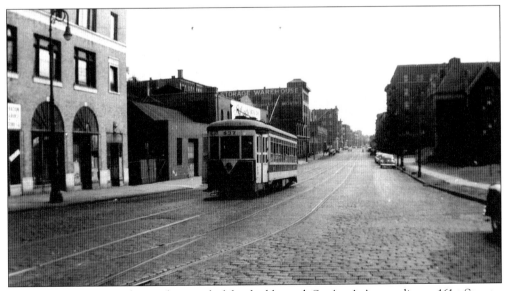

Car No. 637 appears at the northern end of the double-track St. Ann's Avenue line at 161st Street.

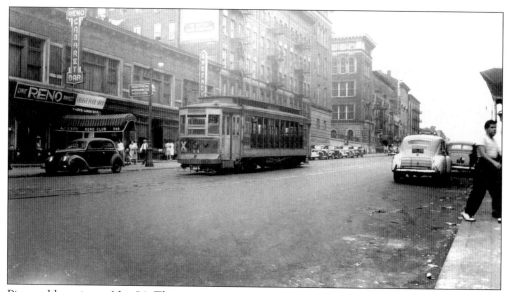

Pictured here is car No. 84. This important crosstown route ran on 149th Street in the Bronx and crossed the Harlem River onto 145th Street in Manhattan. It was one of two major routes that operated on both trolley wire trackage (in the Bronx) and underground conduit system trackage (in Manhattan). The change of current collectors was made at a plow pit near Eighth Avenue and 145th Street.

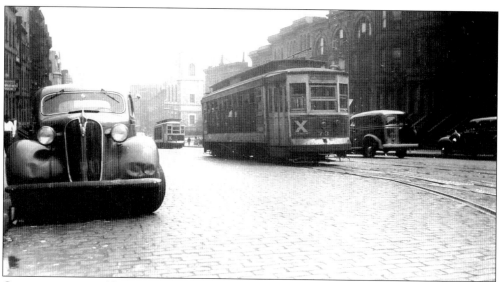

Crosstown convertible car No. 73 operates on conduit trackage on West 145th Street at Amsterdam Avenue. The car is equipped with screens for summer service.

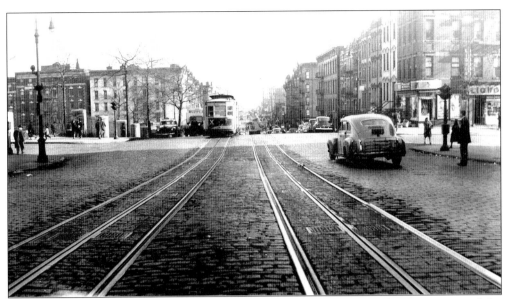

A standard convertible car is westbound on 145th Street on the Manhattan portion of the route in this eastward view from Edgecomb Avenue. This scene clearly shows the standard underground conduit trackage required on all Manhattan lines. The residential buildings in the background are typical of the area.

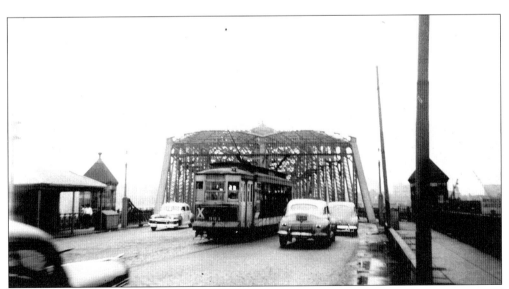

No. 991 prepares to cross the Central Bridge over the Harlem River into the Bronx. East of Eighth Avenue, the cars used overhead trolley wire.

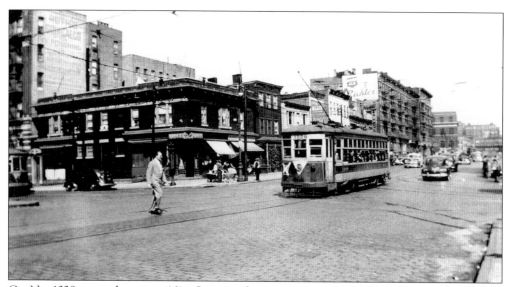

Car No. 1228 proceeds west on 161st Street at the intersection with Melrose Avenue. On the left, a Webster Avenue car is about to cross the intersection. No. 1228 was purchased in 1933 from the Androscoggin and Kennebec Railway in Maine and rebuilt in Third Avenue's car shop.

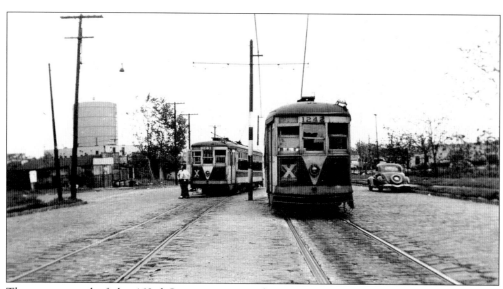

The eastern end of the 163rd Street crosstown line was on Hunts Point Road and Randall Avenue. Car No. 1232 departs on a westbound trip to 155th Street and Broadway in Manhattan. One of the important places (and passenger traffic generators) served by this line is the famous Yankee Stadium.

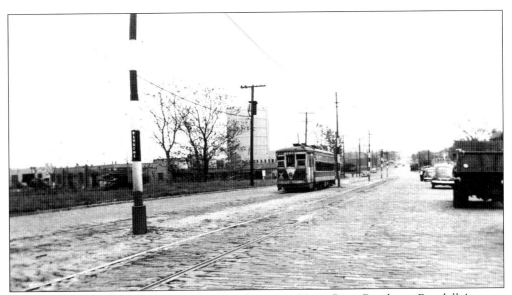

The 163rd Street crosstown car No. 1232 travels west on Hunts Point Road near Randall Avenue. The use of center poles with brackets located between the tracks was rare on the Third Avenue System. The Hunts Point area was a relatively undeveloped section of the Bronx.

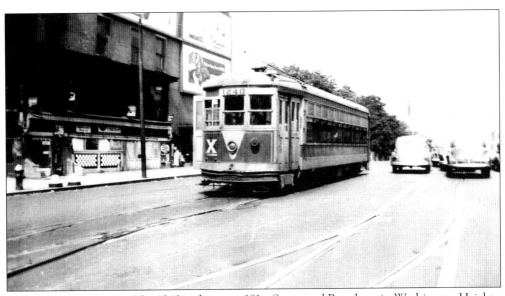

Former San Antonio car No. 1240 is shown at 181st Street and Broadway in Washington Heights. Several Bronx lines that terminated here used overhead trolley wire, permitted by the city on West 155th and 181st Streets traversed by Bronx car lines crossing the Harlem River into Manhattan.

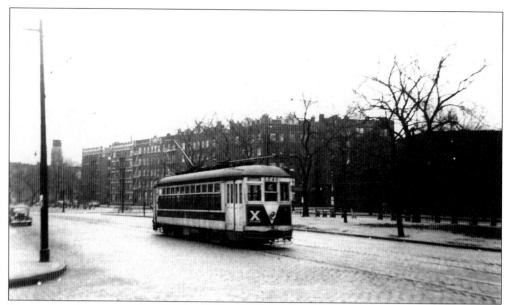

Former San Antonio car No. 1245 heads east on Boscobel Avenue west of Jerome Avenue on the 167th Street crosstown line. In the background are the usual Bronx apartment buildings.

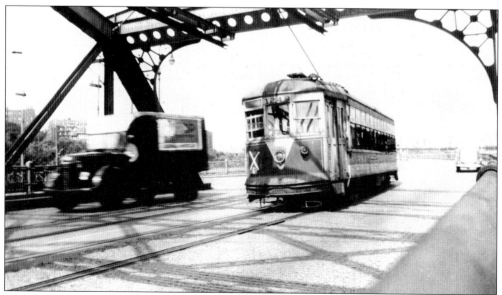

Car No. 1249 enters the Bronx from a bridge over the Harlem River.

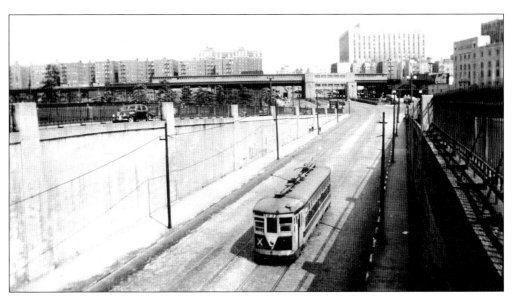

Shown here is car No. 1247 on 167th Street, which intersects the Grand Concourse via an underpass rather than at grade. By 1947, sufficient steel cars were available to replace wooden convertible cars on the 167th Street line. In the background is the IRT Jerome Avenue route.

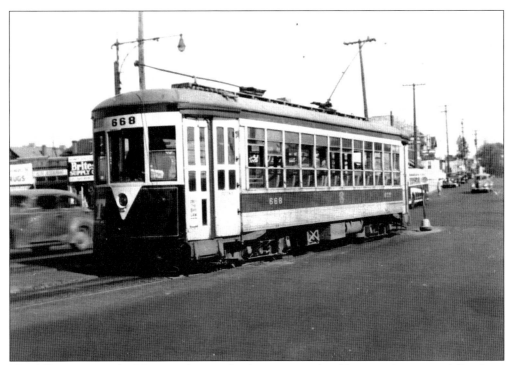

No. 668 appears at the Tremont Avenue line's eastern end at Tremont Avenue and Bruckner Boulevard. This route was equipped with new steel cars in 1939, replacing the wooden cars.

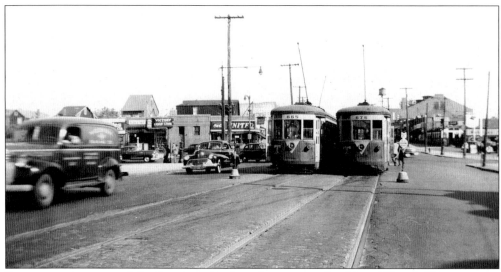

Here is another view of the Bruckner Boulevard terminus. Car Nos. 665 and 676 prepare to reverse direction and travel to the west-central Bronx.

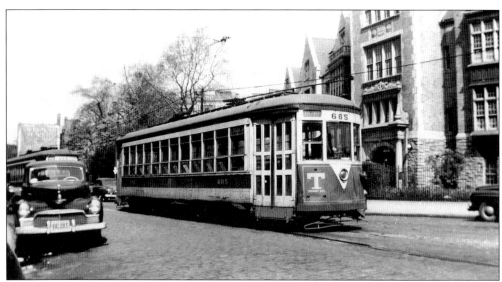

The Tremont Avenue line was a busy crosstown route that terminated in the west Bronx at University and Burnside Avenues, where Tremont line passengers could transfer to University Avenue cars. No. 685, built in 1939 by the Third Avenue Railway, was the last conventional streetcar constructed in the United States.

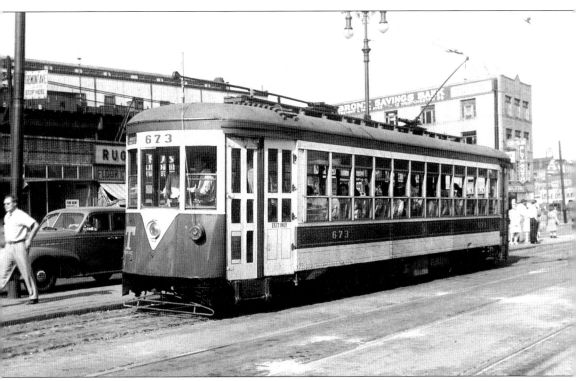

Tremont Avenue car No. 673 is pictured at the West Farms Square streetcar station, an important junction for streetcar passengers. Currently, the Tremont Avenue line is a very heavily traveled bus route.

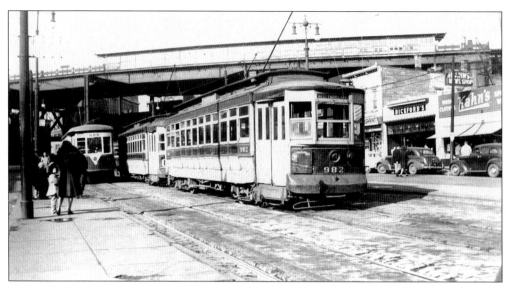

Shown here is car No. 982. This long route ran northwest from West Farms Square in the central Bronx to Broadway and Van Cortlandt Park at the Yonkers city line. Two C-line cars are on the layover track at West Farms Square. This was a very busy streetcar station, with five lines converging here. In the background is the 177th Street station of the IRT.

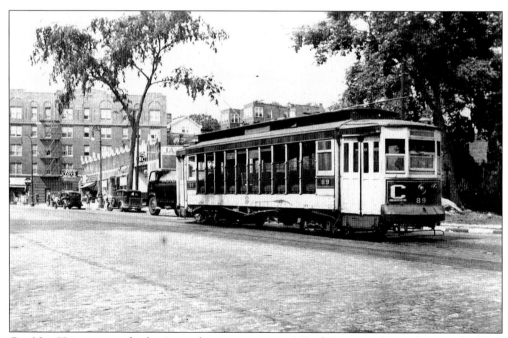

Car No. 89 is seen at the line's northern terminus at 262nd Street and Broadway at the New York City–Yonkers border. Equipped with screens for summer operation, the car prepares to commence its journey to West Farms Square.

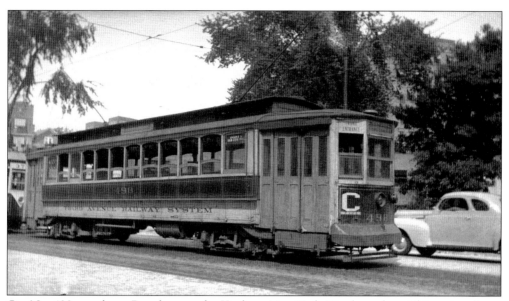

Car No. 498 travels on Broadway at the Yonkers–New York City boundary. This series of cars was out-of-service by 1942 and then sold or scrapped.

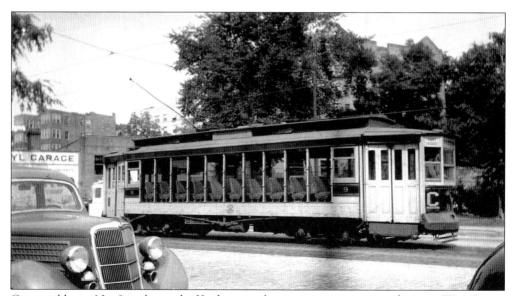

Convertible car No. 9 is also at the Yonkers city line preparing to run southeast to West Farms. From the city line to the subway terminal at 242nd Street, Yonkers Railroad cars operated on Broadway.

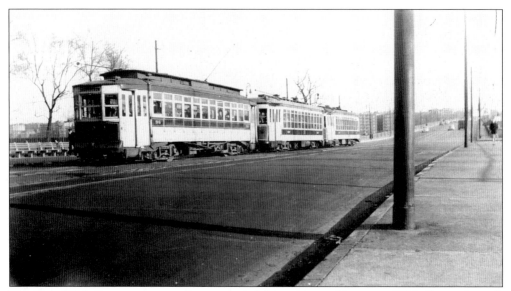

The long 180th Street crosstown line extended from the east Bronx on 177th Street through West Farms Square to 181st Street and Broadway in Manhattan. Here, No. 98 is westbound on the Tremont Avenue section of the line. When steel cars became available, they displaced the wooden convertible cars.

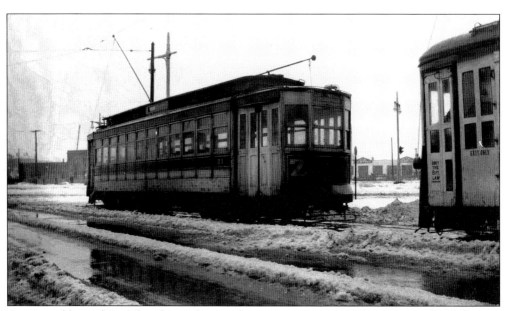

A convertible car (No. 11) and a steel car at the eastern terminus of the Z route, a locale known as Unionport. Like most of the Bronx, it was a residential area as well. In addition to serving local destinations, many Bronx car lines also served as feeders to the rapid transit lines.

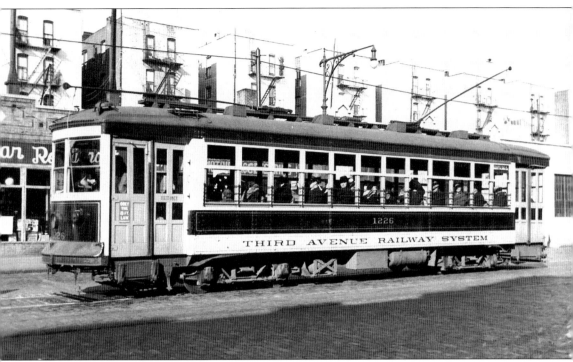

This characteristic scene on Webster Avenue near 167th Street shows No. 1226 with a full load of passengers. This route was Third Avenue's first line to be equipped with lightweight steel cars. No. 1226 was purchased in 1933 from the Northern States Power Company of Eau Claire, Wisconsin.

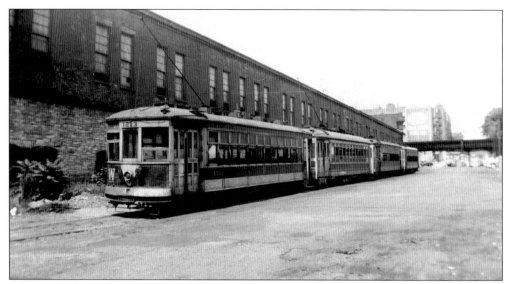

Kingsbridge Depot had two levels. Here, car No. 1213, assigned to Webster Avenue, and three others are on the track leading to the lower level. The W line and other west Bronx routes operated from this depot. In the background is the elevated structure of the upper Broadway line of the Interborough Rapid Transit.

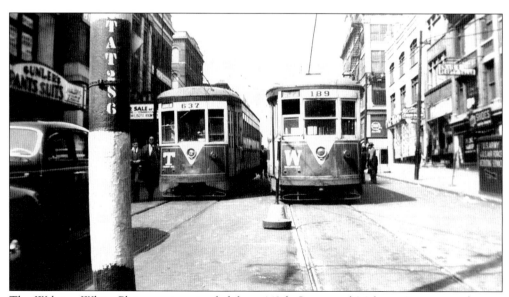

The Webster–White Plains route extended from 149th Street and Melrose Avenue north on a direct route via Webster Avenue and White Plains Road to the Mount Vernon city boundary line. Car No. 189 prepares to depart from 149th Street, and No. 637 serves as an excursion car tour.

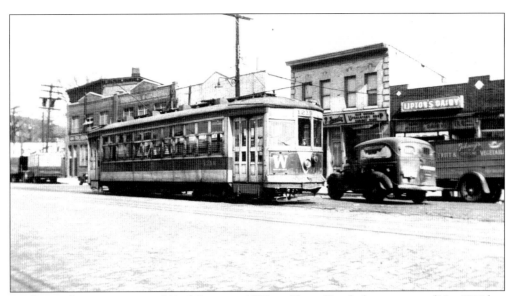

At the northern terminus at 242nd Street and White Plains Road, the operator of No. 1219 has changed ends and is ready to return to 149th Street. This lot of cars numbered 1201 to 1225 was acquired in 1933 from Richmond Railways in Staten Island, and all were assigned to the Webster Avenue line.

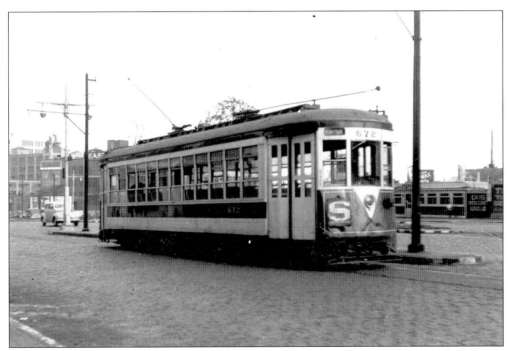

The Southern Boulevard line extended from Fordham Road south to 138th Street. In 1939, 40 of the newly built cars of the 626–685 series were assigned to this line and Tremont Avenue, displacing obsolete wooden cars. Car No. 672 is viewed st the southern terminus at 138th Street.

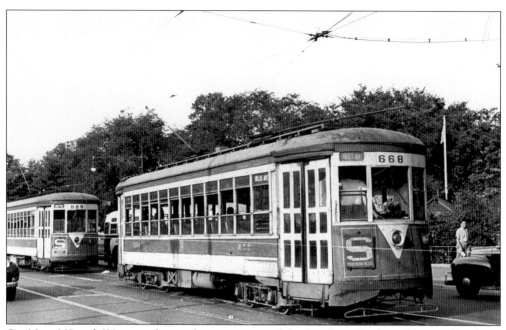

Car Nos. 668 and 629 are at the northern terminus of the Southern Boulevard line, at Southern Boulevard and Fordham Road. In the right background is Bronx Park.

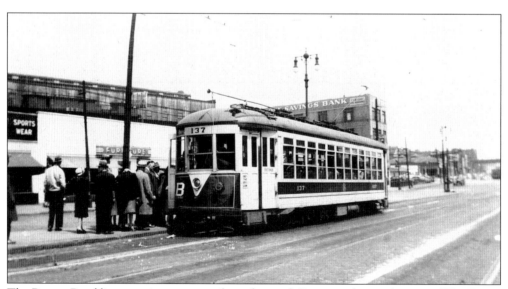

The Boston Road line, a major route, ran from the south Bronx to the northeast via West Farms Square. Here, northbound car No. 137 boards passengers at West Farms Square. No. 137 was a former Manhattan steel car equipped with trolley poles and transferred to Bronx service.

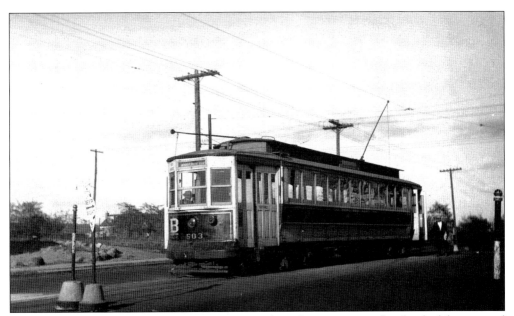

The B line's northeastern terminus was in a relatively open area of individual homes and undeveloped lots at Morris Park Avenue and Williamsbridge Road. Prior to assignment of convertible cars to this service, older side-seating wooden cars of this type were used. By 1940, cars like No. 503 were being phased out and scrapped or placed in storage pending disposition.

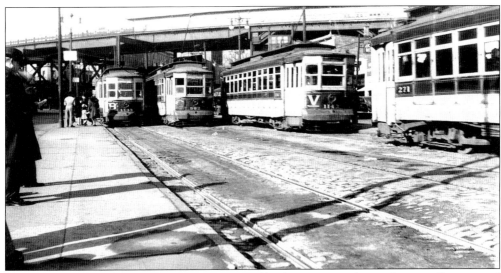

The West Farms Square trolley station was served by five routes, making it busy at all times, and it was also a major transfer point. Adjacent is the 177th Street station of the Interborough Rapid Transit. Northbound Boston Road car No. 1133 is boarding passengers, while No. 982 rests on the center layover track, allowing cars of other lines to pass. The C line terminated here.

Southbound Boston Road car No. 31 travels west on Tremont Avenue into West Farms Square. In the background is an Interborough train en route to the East 180th Street station.

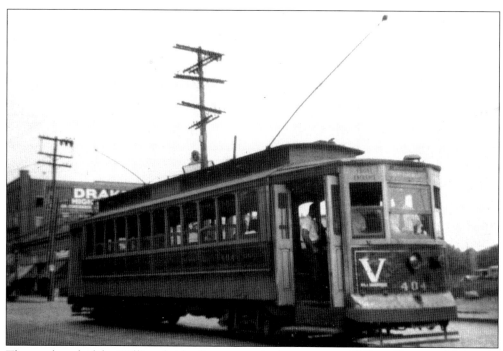

The north end of the Williamsbridge line was at the intersection of White Plains and Gun Hill Roads. A 400-series car is reversing direction at this point. This class of long, longitudinal seat cars was retired by 1942 and scrapped or sold.

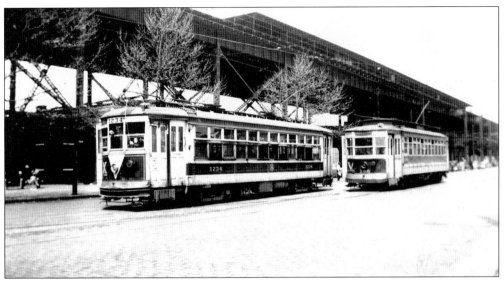

Excursion car No. 1234 is viewed on White Plains Road at Gun Hill Road with V-line car No. 280. Above is the IRT White Plains Road elevated, which extended north to 241st Street.

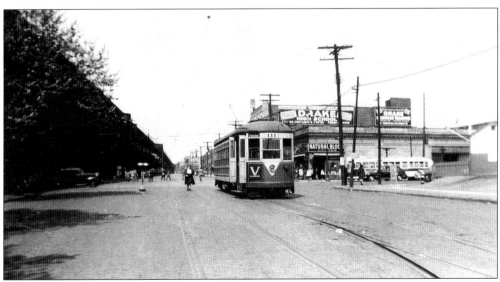

A Williamsbridge-line car appears at the end of the route. Former Manhattan steel cars like No. 111 were transferred to the Bronx in 1947, replacing obsolete wooden convertible cars.

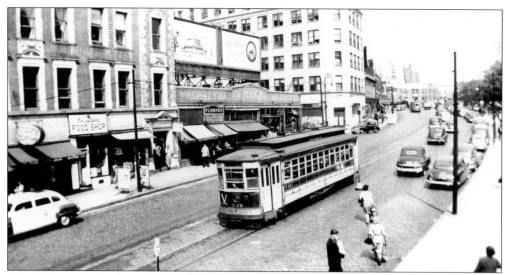

The Williamsbridge line extended south to West Farms Square and then west on Tremont Avenue to Third Avenue in the heart of central Bronx.

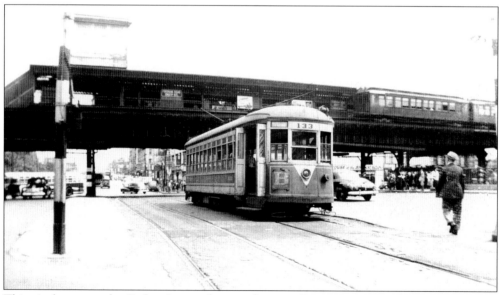

This single-car on the Bailey Avenue line in the west Bronx was a so-called franchise line maintained only to provide a convenient route for approximately 200 cars moving from Kingsbridge Depot to their assigned routes and returning. Car No. 133 is seen at Fordham Square, located on Fordham Road between Third and Webster Avenues. Adjacent are the Third Avenue elevated and the campus of Fordham University.

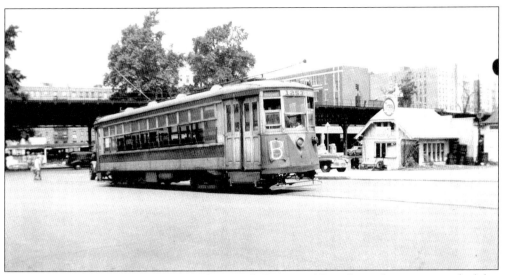

Bailey Avenue car No. 1253 is pictured at 230th Street and Broadway, the western end of this short line. Cars running on and off their assigned routes turned onto Broadway and crossed the Harlem River Bridge to Kingsbridge Depot.

Bailey Avenue car No. 23 travels on Fordham Road near Jerome Avenue.

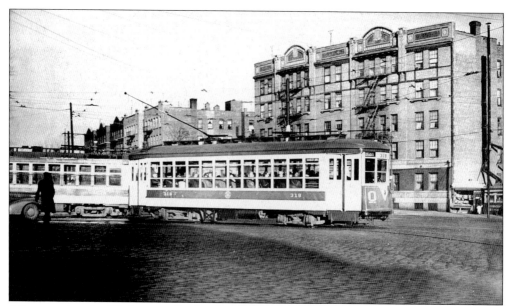

After crossing the Washington Bridge from Manhattan, Ogden Avenue car No. 318 runs on 181st Street and University Avenue, heading south to 161st Street. To the left, a University Avenue car is northbound.

Pictured here is car No. 208. Sedgewick Avenue was another short, single-car line in the west Bronx. It was a remnant of a once-longer route and served a residential area near the Harlem River. From its terminus at University and Burnside Avenues, it ran down to Sedgwick Avenue.

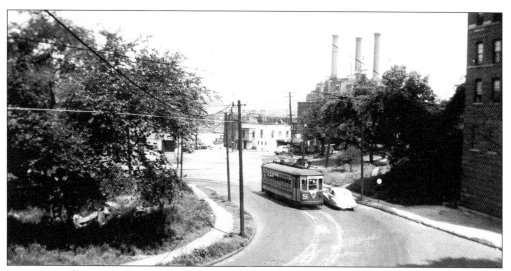

Former Manhattan steel cars replaced many of the wooden convertible cars. Here, No. 191 starts up the Burnside Avenue hill to University Avenue on the Sedgwick Avenue line.

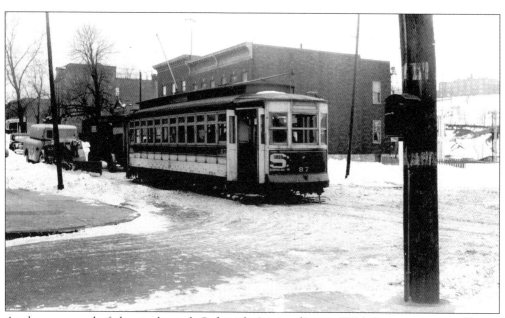

At the outer end of the single-track Sedgwick Avenue line at 190th Street is convertible car No. 87. This was the only single-track line in the Bronx.

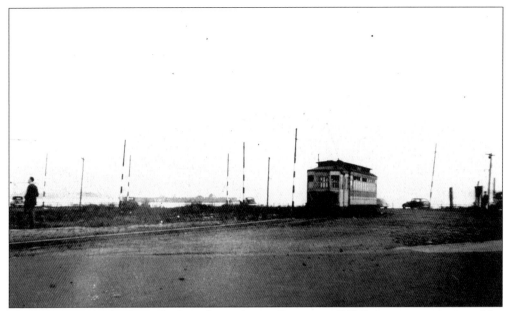

Shown here is car No. 62 on the Soundview Avenue line, route "V." Prior to construction of the Bronx-Whitestone Bridge, a ferry service connected Clason Point in the Bronx with College Point in Queens. From a loop at Clason Point, this line operated on Soundview Avenue to Westchester Avenue, connecting with cars on that line and the IRT Pelham Bay line. The ferry service provided many passengers for this route. In the background are the East River and Long Island Sound.

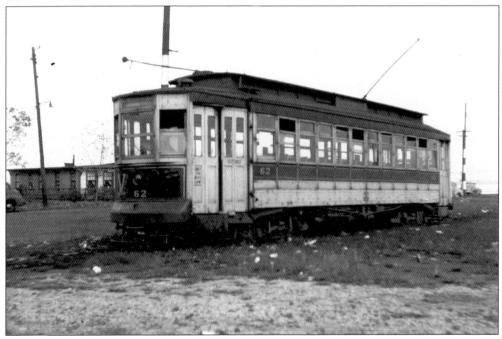

The Bronx had more streetcar lines than available letters; therefore, some routes had duplicate but non-conflicting letters, such as two routes labeled "V." Here, car No. 62 departs from the ferry terminal loop on the Soundview Avenue line.

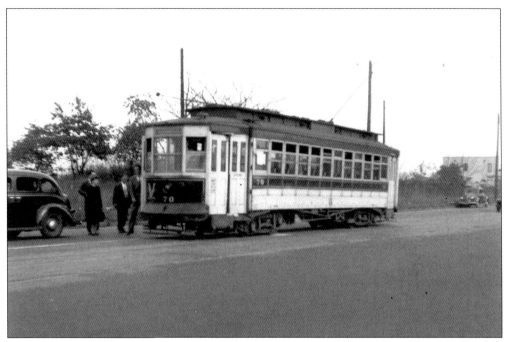

In addition to being a ferry connection, this line also served the residential area adjoining Soundview Avenue. Here, passengers board car No. 70 on Soundview Avenue.

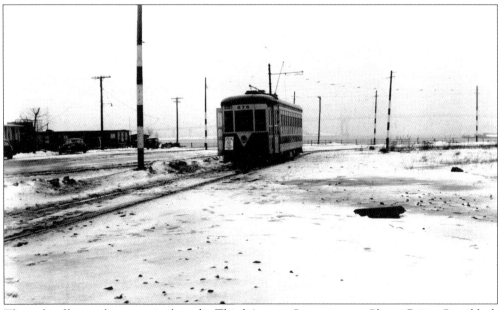

The only off-street loop terminal on the Third Avenue System was at Clason Point. On a bleak wintry day, excursion car No. 676 appears on the loop track.

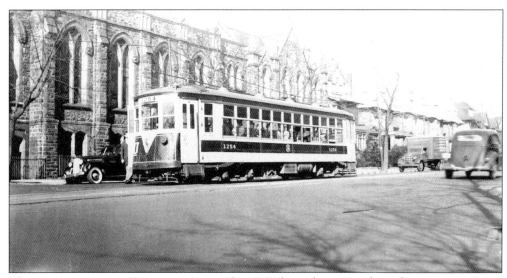

This west Bronx street University Avenue line "U" derived its name from the presence of New York University's Bronx campus. The route extended from 181st Street and Broadway to 238th Street and Broadway via Washington Bridge (crossing the Harlem River) and University Avenue. Previously owned lightweight steel cars acquired in 1933 to 1934 were assigned to this line. In the background is New York University, where No. 1254 has paused to receive passengers.

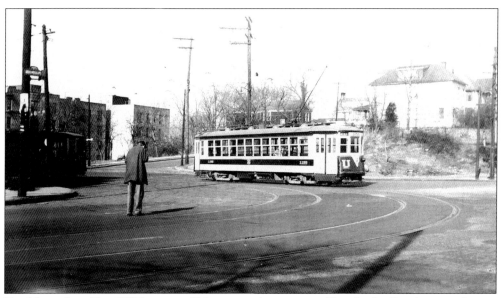

Northbound car No. 1255 has exited University Avenue onto Kingsbridge Road, proceeding to its terminus at 238th Street and Broadway.

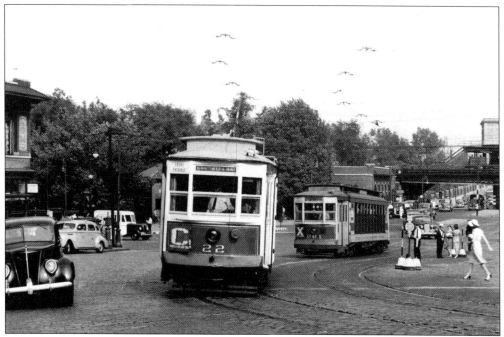

Bronx and Van Cortlandt Parks car No. 22 is at Fordham Square, while No. 281 travels on the 207th Street crosstown line.

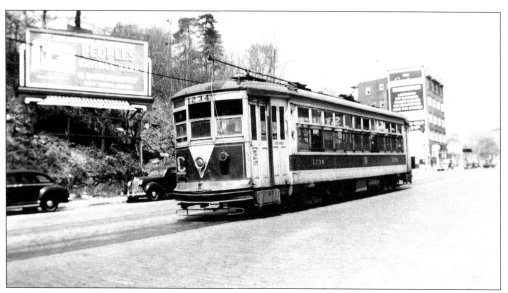

Former San Antonio car No. 1234 is on Broadway at Van Cortlandt Park on the "C" line.

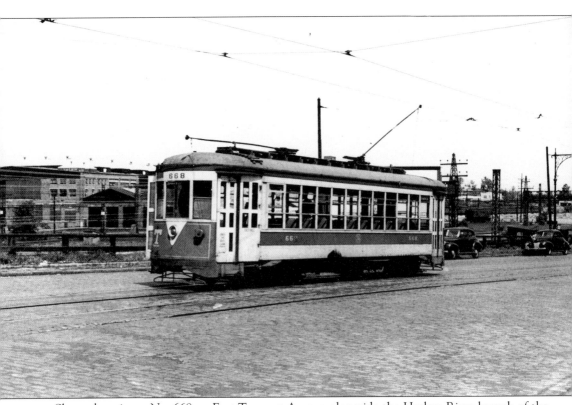

Shown here is car No. 668 on East Tremont Avenue alongside the Harlem River branch of the New Haven Railroad, now the Hell Gate Bridge line of Amtrak. In the background is New Haven's large Van Nest electric locomotive and car shop.

Three

THE YONKERS RAILROAD

The city of Yonkers in southern Westchester County is located immediately north of the Bronx on the east bank of the Hudson River. It is large in area, but the majority of its population resides in its western part. The Yonkers Railroad Company was initially independent, but in 1898 its capital stock was purchased by the aggressively expanding Third Avenue Railroad Company, which at the same time also purchased control of the Union Railway Company. The Bronx lines of the Union Railway connected with the Yonkers Railroad system, thus enlarging Third Avenue's growing streetcar monopoly. The Yonkers streetcar lines formed a compact network in the western part of the city and a cross-county line to Mount Vernon. Similar to many smaller cities, all car lines passed through the center of downtown Yonkers: Getty Square.

Even though the Yonkers Railroad was part of the vast Third Avenue Railway System, it was operated as a separate division from a three-level car house on Main Street, next to the Hudson River and the New York Central Railroad station. The Yonkers Railroad had nine routes, the most important of which were the heavily traveled Broadway lines connecting with the IRT Broadway line, completed in 1904, plus the long cross-county route to Mount Vernon. Unlike other parts of the system, the Yonkers lines were designated with numbers instead of letters. Routes numbered 2, 4, and 7 were double-track in their entirety, but the others were single-track with passing sidings. The Yonkers Railroad was unusual (or possibly unique) because it did not operate buses but did run school cars.

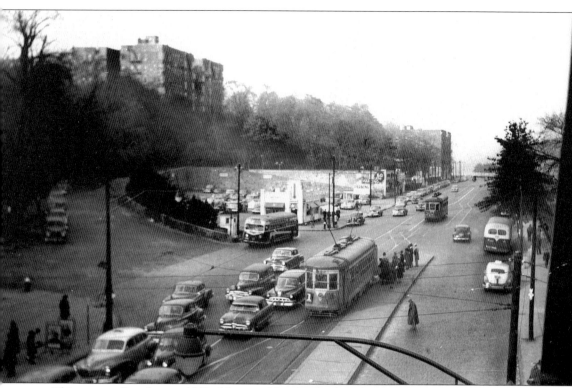

This scene, at Broadway and 242nd Street at Van Cortlandt Park, shows the northern terminus of the IRT West Side subway-elevated line and the southern end of the Yonkers Railroad Broadway lines. The interchange of passengers between streetcar and rapid-transit lines made this a very busy terminal. Three Yonkers routes maintained a base five-minute headway on Broadway: No. 1, Broadway–Park Avenue; No. 2, Broadway–Warburton Avenue; and No. 3, Broadway-Yonkers. Operating flexibility required a third layover, or pocket track, at this terminal, as seen in the photograph.

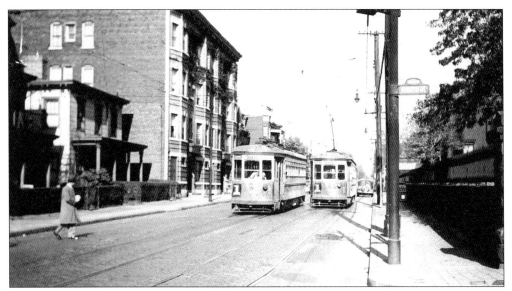

North of the city center at Getty Square, Route No. 1 operated on Warburton Avenue to the Yonkers-Hastings boundary. This section was single-track with passing sidings. Here, southbound car No. 306 passes No. 386 at a typical turnout.

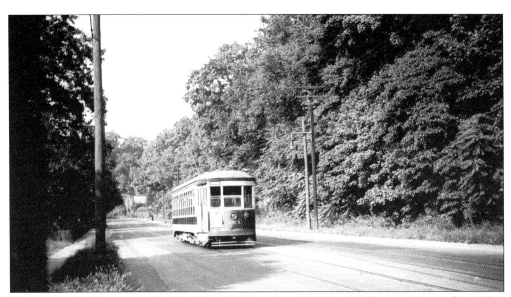

This is a typical scene on the double-tracked north end of the Warburton Avenue line. This section of the route was wooded and undeveloped at that time.

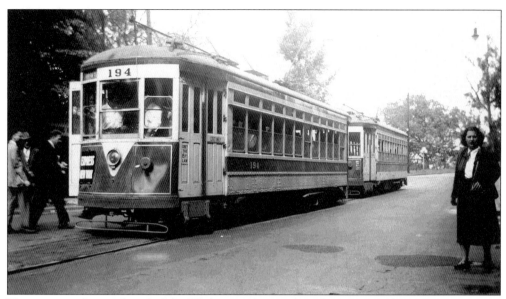

This view on the north end of the Warburton Avenue line shows a special excursion car and a regular car. The author's wife looks on from the side.

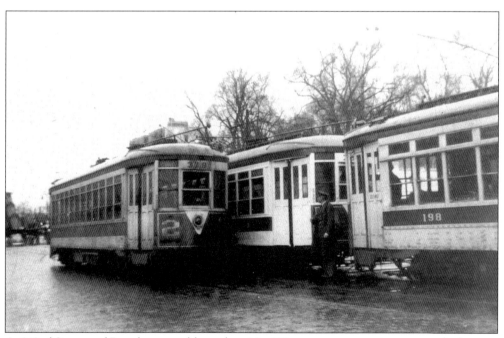

At 242nd Street and Broadway, northbound car No. 379 passes two excursion cars on the layover, or pocket track.

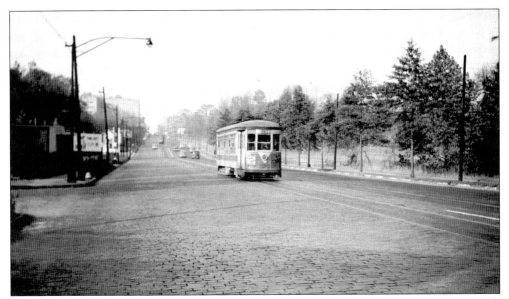

Broadway–Park Avenue car No. 397 moves swiftly south on Broadway a short distance south of the Yonkers–New York City boundary en route to the IRT terminal at 242nd Street. On the right is Van Cortlandt Park.

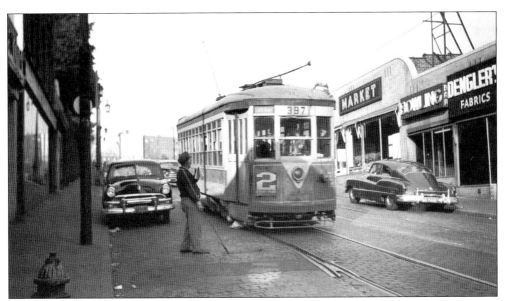

Similar to Pittsburgh and Cincinnati, Yonkers is a city of hills. The severe grade on Palisade Avenue required two manually operated derails to avoid the possibility of a runaway car. Around 1930, an out-of-control car lost its air brake on this hill and crashed into a building at the bottom of the grade, prompting the installation of the derails. In addition, all 300-series cars assigned to Yonkers were equipped with dynamic brakes to prevent such incidents.

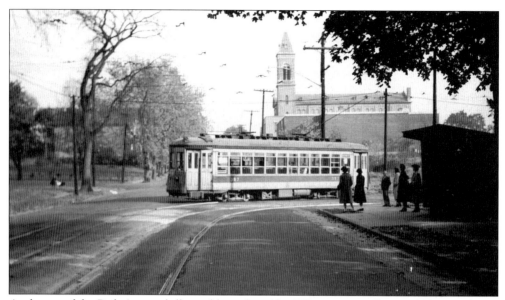

At the top of the Park Avenue hill, northbound car No. 397 turns onto Shonnard Place on Route No. 2. Potential passengers wait on the corner for a city-bound car. Near this location stands Gorton High School, to which many students traveled by streetcars designated "School Car."

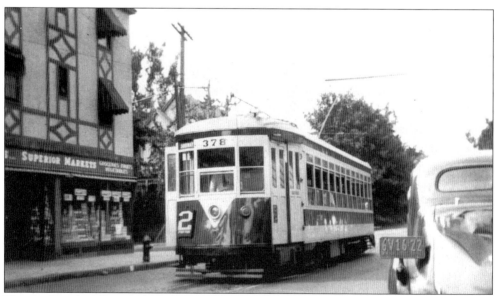

The north end of the Broadway–Park Avenue line was on Palisades Avenue at Roberts Avenue. Car No. 378 has just completed a trip and prepares to head south to Getty Square and then on to 242nd Street and Broadway.

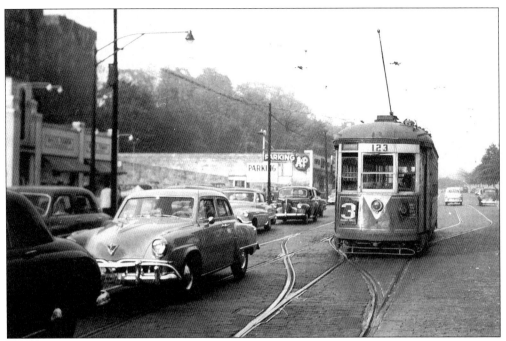

The passenger traffic on Broadway north of the IRT subway-elevated terminal was so large that frequent service provided by Routes 1 and 2 cars was at times insufficient. Additional capacity was furnished by cars operated between the subway terminus and Getty Square, designated Route No. 3.

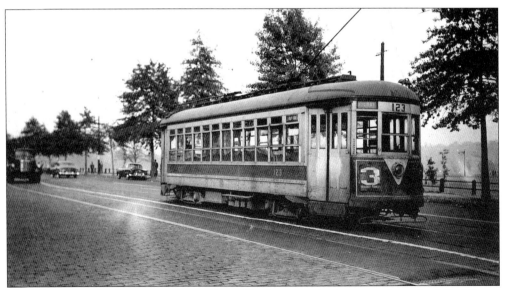

No. 123 rests on the layover track as a Route No. 3 car awaits departure from the 242nd Street station for Getty Square in Yonkers.

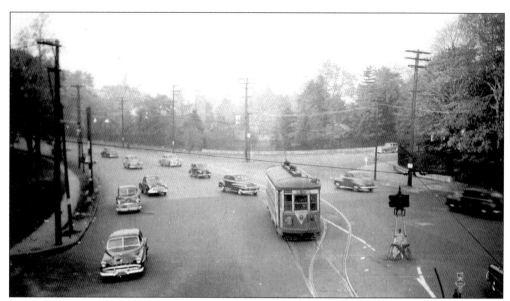

The McLean Avenue line connected a large section of Yonkers with the Jerome Avenue IRT subway-elevated line at Woodlawn and Jerome Avenue. This line extended from Main Street to Woodlawn via Main and New Main Streets, Broadway, McLean Avenue to Central Park Avenue, and Jerome Avenue. Car No. 357 approaches the Woodlawn terminal.

Car No. 341 travels Jerome Avenue in the Bronx en route to the Woodlawn IRT station. The streetcars ran express service between the IRT terminal and the Yonkers city line with no stops. Note the wide separation of the double track on this street.

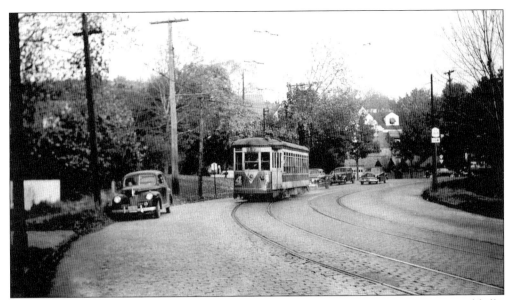

The McLean Avenue line was typical of the Yonkers car lines with its many curves and hills. Car No. 357 heads toward Yonkers's center and its terminus at the foot of Main Street.

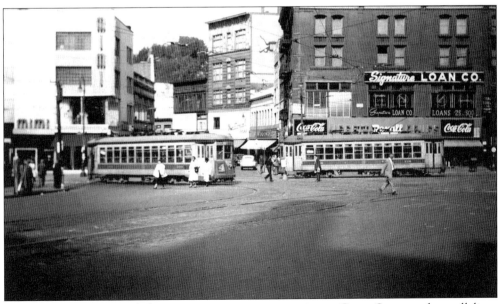

This is a typical view of the continuous streetcar activity at Getty Square, where all lines converged. All but one street leading to the square had streetcar trackage.

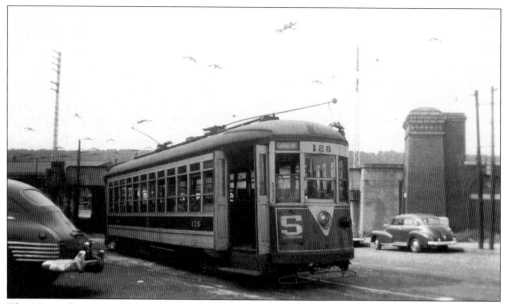

The Nepperhan Avenue line, Route No. 5, operated from the foot of Main Street via downtown streets and Nepperhan Avenue to the northern part of the city, terminating at the Hastings boundary. Car No. 126 is signed up for this line on the car house lead track.

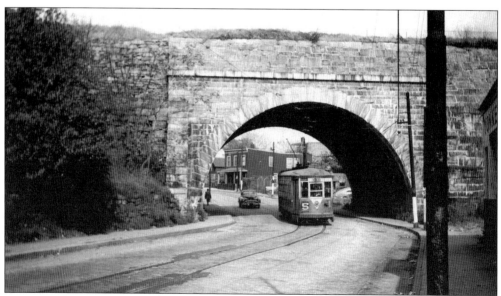

In the 1840s, the city of New York built the first part of its vast water supply system. Water flowed to the city from the Croton Reservoir and through the Croton Aqueduct, which passes through Yonkers. Here, car No. 340 travels under the aqueduct on Nepperhan Avenue.

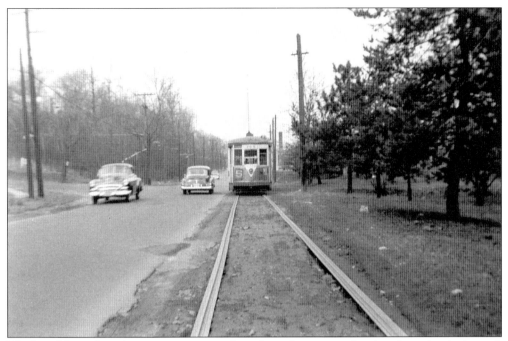

The long Nepperhan Avenue route operated on the only street in the city where the single track was located on a roadside right-of-way. This is a typical scene on Nepperhan Avenue near Odell.

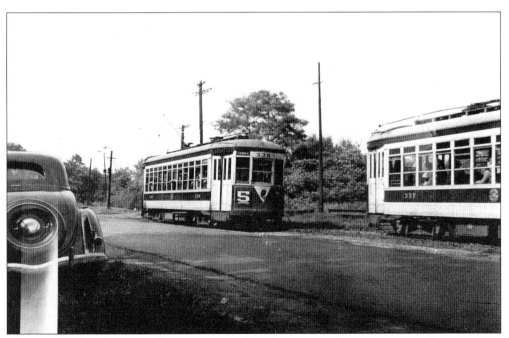

The outer end of Route No. 5 was single-track with passing sidings or turnouts that permitted opposing cars to pass. Near Odell Avenue, car Nos. 337 and 339 pass each other.

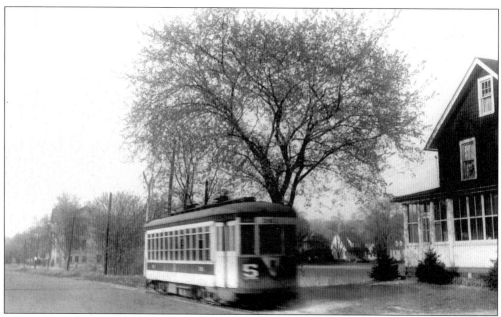

The north end of Nepperhan Avenue was lightly developed and semi-rural in appearance around 1940. The car line retained its original roadside construction, as seen here with car No. 360 proceeding outbound.

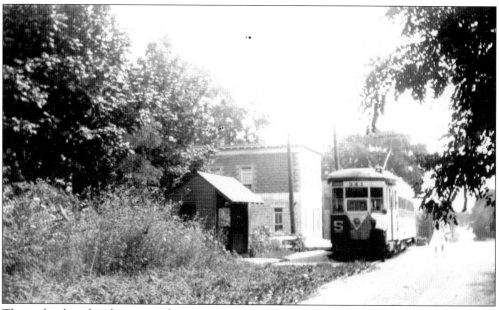

The undeveloped real estate at the outer terminus of Route No. 5 at Tomkins Avenue gave the impression that the line ended in a rural area. On the left is a shelter for waiting passengers. The motorman, or operator, prepares for the return trip to Yonkers center by changing trolley poles.

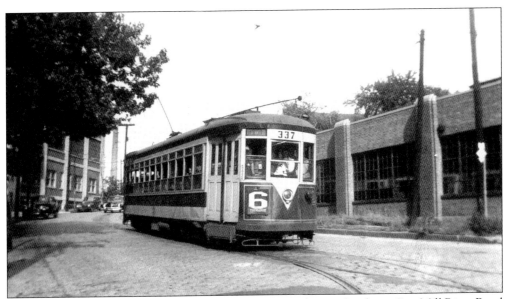

The No. 6 line extended from the foot of Main Street to the north side via Saw Mill River Road and Tuckahoe Road, terminating at Nepperhan Station of the New York Central Railroad's Putnam Division (now abandoned). This route passed the large mill of the Alexander Smith Carpet Company. Car No. 337 is at Lake Avenue and Saw Mill River Road. On the left is a carpet mill building.

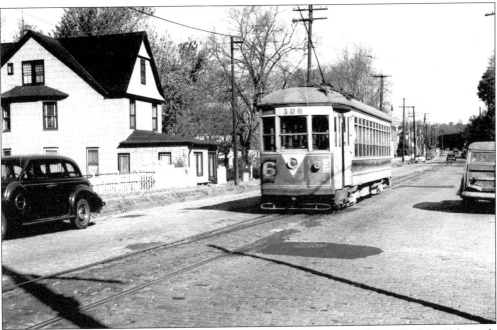

On Saw Mill River Road, Route No. 6 was single-track with passing sidings. Car No. 106 travels on a typical section of this street.

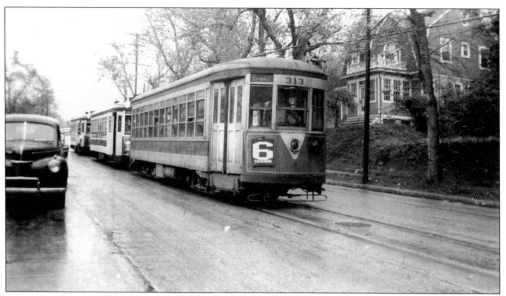

A regular service car and two chartered excursion cars rest at the terminus on Tuckahoe Road at Nepperhan Station.

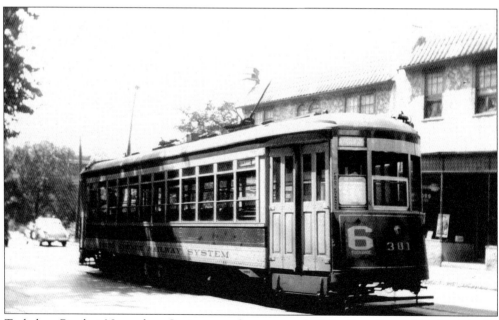

Tuckahoe Road at Nepperhan Station was the outer end of the line. Route No. 6 originally extended east through a thinly populated rural area to the village of Tuckahoe but had been cut back many years previous.

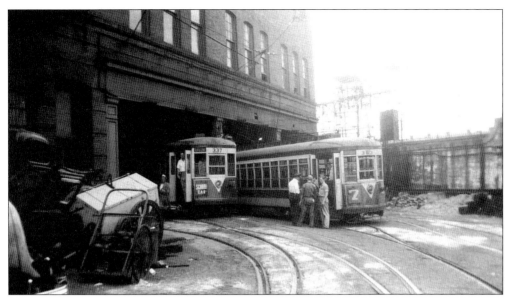

This interesting scene shows the front of the Yonkers car house and, in the background, the viaduct of the New York Central Railroad. Ready to pull out is car No. 363, signed for service on Route No. 7. Alongside, No. 337 bears the sign "School Car." The Yonkers Railroad operated special school cars transporting students on several lines to and from Gorton High School, located on the Park Avenue line.

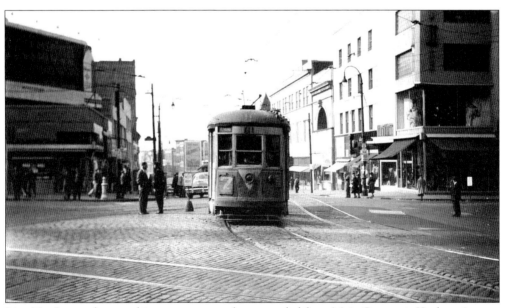

Line No. 7 was a long and important route that extended from Main Street via Yonkers Avenue cross-county to Mount Vernon, where passengers could transfer to another streetcar line for Pelham and New Rochelle. Car No. 111 passes through Getty Square and will soon traverse hilly Yonkers Avenue to Mount Vernon. At this time, one could travel by streetcar from the Hudson River all the way to Long Island Sound.

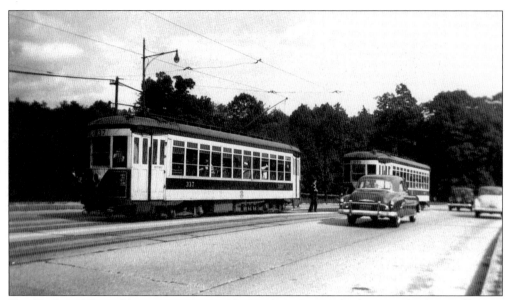

Two Yonkers–Mount Vernon cars pass on the Yonkers Avenue bridge over the Saw Mill River Parkway. Route No. 7 was the first in Yonkers to receive the new steel lightweight cars as part of Third Avenue's 1930s equipment modernization program.

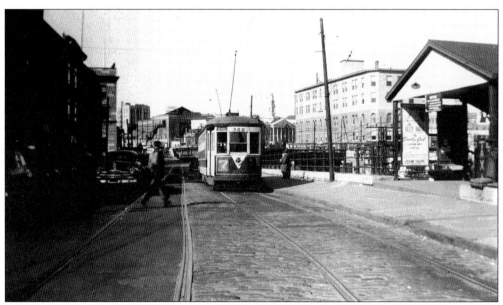

Car No. 322 has completed its trip from Yonkers to the terminus at the New Haven Railroad station on East First Street in Mount Vernon.

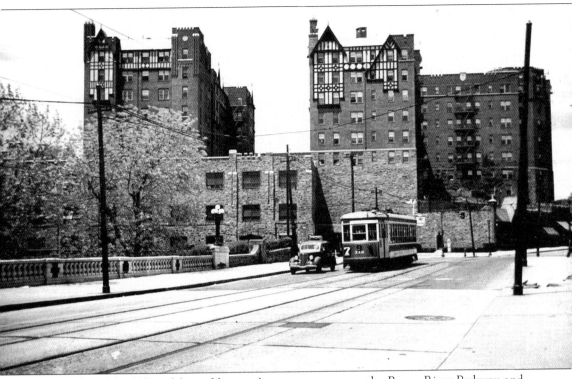

Eastbound car No. 312 on Mount Vernon Avenue crosses over the Bronx River Parkway and prepares to pass under the West Mount Vernon station of the New York Central Railroad (now Metro North Railroad).

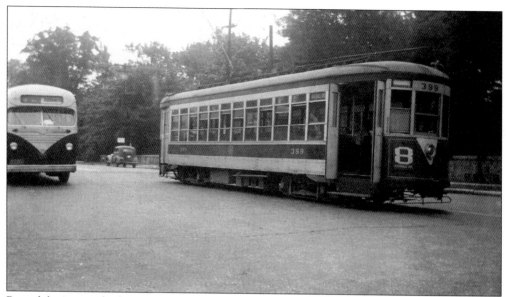

Riverdale Avenue had its own car line extending south from Main Street to the New York City boundary at Mount St. Vincent. It was also a single-track line with passing sidings. Car No. 399, shown here at the route's south end, was one of two cars assigned to the line.

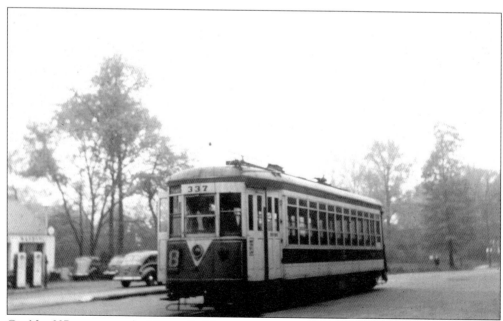

Car No. 337 appears at the Mount St. Vincent terminus.

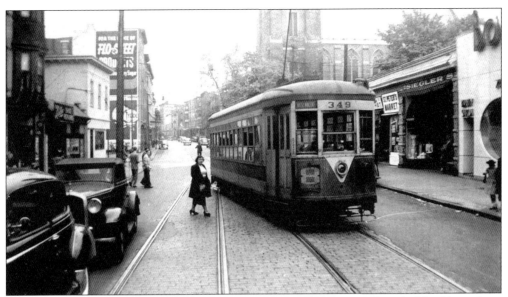

Riverdale Avenue paralleled Broadway from Main Street for its entire length. Northbound car No. 349 has just passed another car, a typical occurrence for single-track lines.

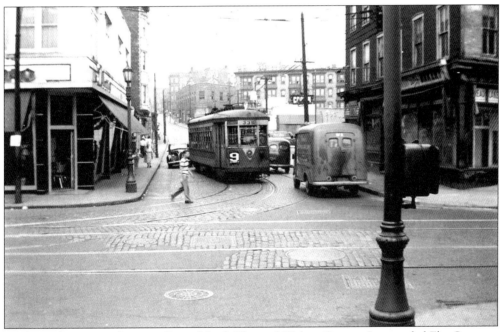

Yonkers's shortest car line was Route No. 9, Elm and Walnut Streets. It ascended Elm Street to the summit of one of the city's many hills. Car No. 335 has descended the steep grade on its way to its terminus at the foot of Main Street. Only one or two cars were required to serve this line.

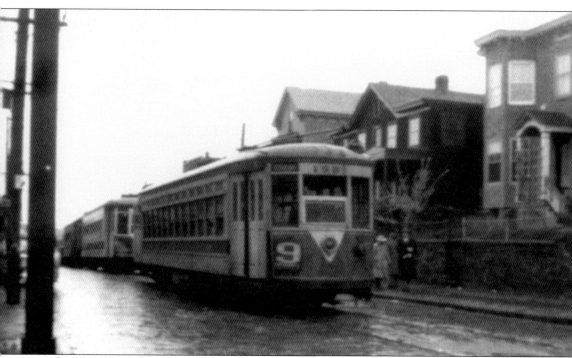

Car No. 198, at the summit of Elm Street, awaits its scheduled departure time. Also present are two chartered excursion cars.

Four

THE WESTCHESTER
ELECTRIC RAILROAD

When the Third Avenue Railroad Company purchased control of the Union Railway Company in 1898, it also acquired Union's subsidiary, the Westchester Electric Railroad Company, owner and operator of street railway lines in Mount Vernon, Pelham, and New Rochelle. Aside from the later purchase of the New York City Interborough Railway, this acquisition rounded out Third Avenue's extensive streetcar network, which now extended from New York's city hall through Manhattan and the Bronx, to southern Westchester County. The Westchester Electric Railroad operated several local car lines in these municipalities, but by 1939, all were converted to bus operation. The company continued to operate two major streetcar lines: one from 229th Street and White Plains Road in the Bronx to Mount Vernon; the other from 241st Street and White Plains Road to Mount Vernon, Pelham, and New Rochelle. As part of the 1930s car construction program, these lines were equipped with new cars. The Yonkers–Mount Vernon route shared some trackage with these lines.

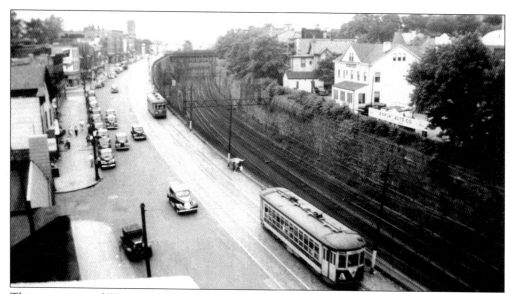

This panorama of West First Street in Mount Vernon was photographed from the upper floor of a building. Adjacent to the street is the below-grade cut of the New Haven Railroad. The unusual off-center location of the streetcar tracks is the result of a municipal fiasco: an extensive project that would have covered the railroad right-of-way and created a wide street with car tracks in the center. Failure of the project left the tracks stranded on the north side of the street with the eastbound track in an awkward position with respect to vehicular traffic. Cars of both Westchester lines and the Yonkers route operated on this trackage.

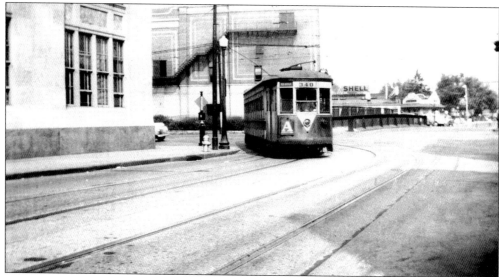

En route to Pelham and New Rochelle, car No. 340 turns from West First Street onto South Fifth Avenue in downtown Mount Vernon. This location was an important passenger boarding and transfer point.

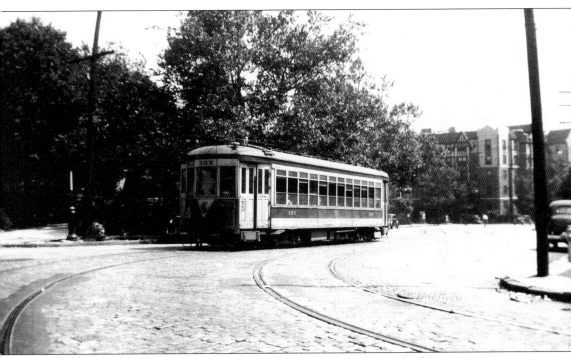

Westbound car No. 305 proceeds from South Fulton Avenue onto East Third Street, en route to the 241st Street and White Plains Road IRT terminal in the Bronx.

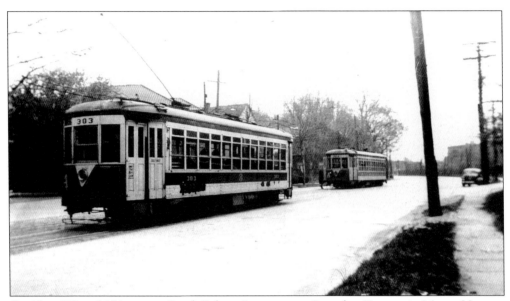

Car Nos. 303 and 304 pass on South Fulton Avenue, near Langdon Terrace, in Mount Vernon. This line was double-track in its entirety.

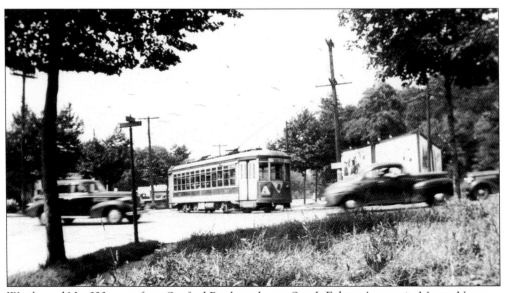

Westbound No. 323 turns from Sanford Boulevard onto South Fulton Avenue in Mount Vernon.

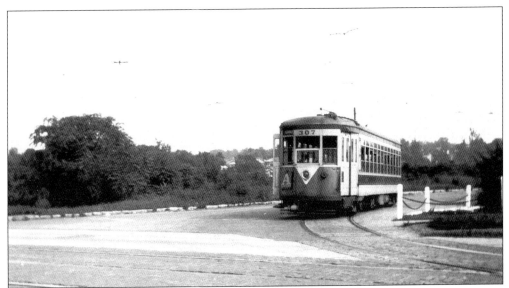

The Westchester Electric cars were based at the Mount Vernon car house and yard at Sanford Boulevard and Garden Avenue. Car No. 307 prepares to depart from the yard to enter service on the A line.

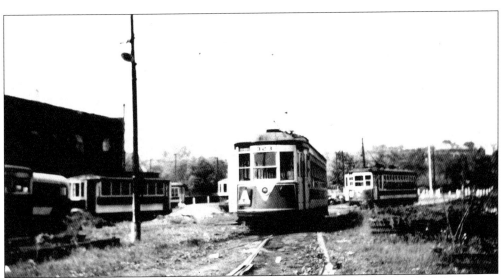

In this view of the Mount Vernon yard, car No. 323 is signed for the A line. To the left is the car house and inspection and repair shop with a capacity of four cars. The shop was equipped with a car hoist, which made it possible to repair or change trucks if necessary. The single-truck car on the left is car No. 316, now preserved at the Branford Electric Railway Museum in Connecticut.

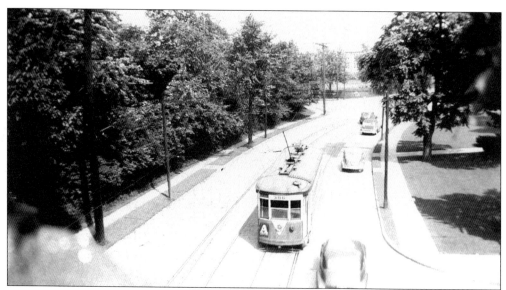

Photographed from the parkway overpass, car No. 306 proceeds through Pelham toward New Rochelle. In the background is Pelham High School.

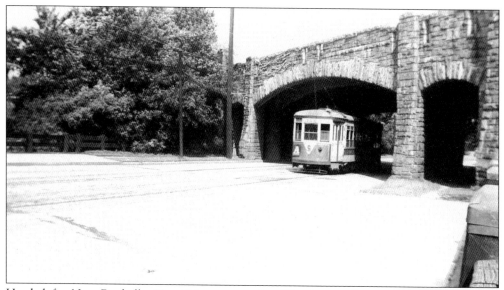

Headed for New Rochelle, No. 326 passes under Westchester County's Hutchinson River Parkway and enters the Pelham portion of the line. Note the handsome stone exterior facing of the bridge.

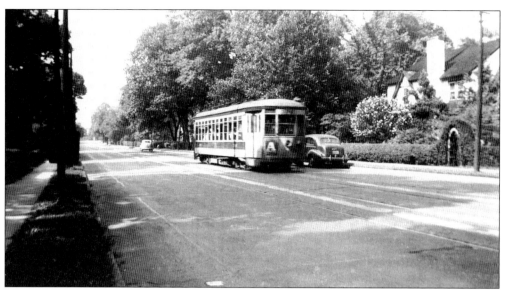

Much of the A line traversed typical suburban residential areas. En route to Mount Vernon, car No. 315 moves rapidly along Pelhamdale Avenue in Pelham.

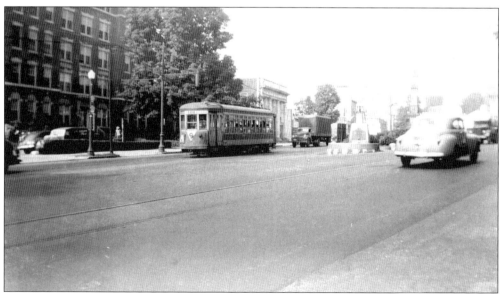

At the junction of Main and Huguenot Streets in New Rochelle, the line's double track split to form a long, single-track loop through the downtown section via Main Street, North Avenue, the Mechanic Street terminal, and Huguenot Street.

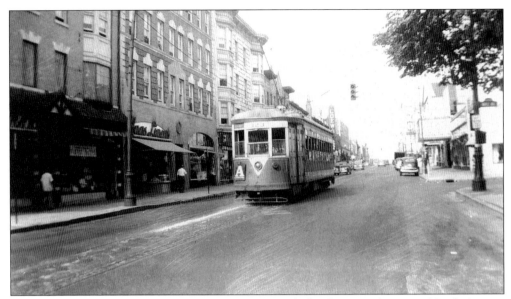

Car No. 323 proceeds east on Main Street in New Rochelle's business district to North Avenue and its layover at the trolley terminal.

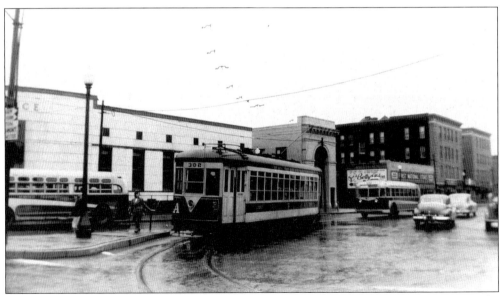

Having traversed Main Street and North Avenue, car No. 302 turns onto Huguenot Street. In the background is the New Rochelle Post Office, erected in the 1930s as a Federal Public Works project.

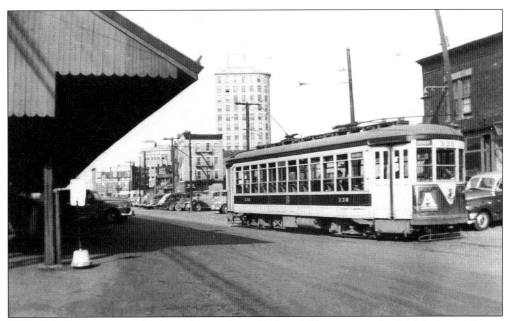

From Huguenot Street, the line detoured via Railroad Place to reach the Mechanic Street terminal, adjacent to the New Rochelle station of the New Haven Railroad.

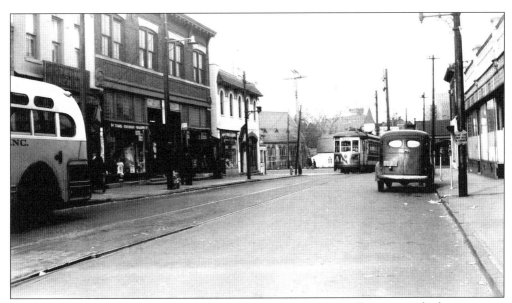

Car No. 324 approaches its layover at the Mechanic Street trolley terminal, the two-story building in the left center. The sign over the entrance reads "Westchester Electric Railroad Company." At the height of the streetcar era, six Third Avenue car lines plus New York and Stamford Railway cars headed for Stamford, Connecticut, used this terminal. At the rear of the building was an off-street siding used to store a spare car.

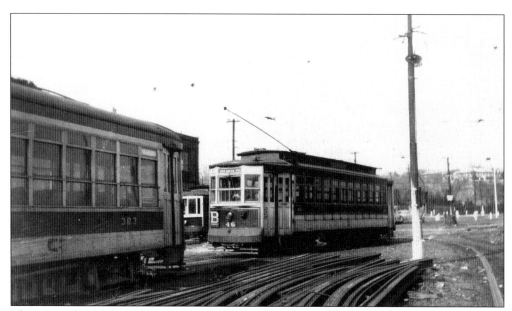

This view of the Mount Vernon car yard was taken during World War II. The huge increase in wartime passenger traffic required additional cars on both the A and B lines. Consequently, several wooden convertible cars were assigned to Mount Vernon to supplement the steel 300-series cars. Here, convertible car No. 46 prepares to depart for service on the B route.

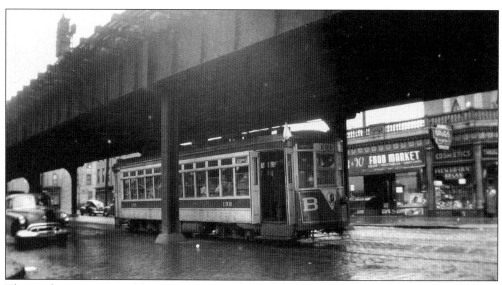

The southern terminus of the B route was at 229th Street and White Plains Road, under the IRT elevated line. Car No. 198 readies to return to Mount Vernon.

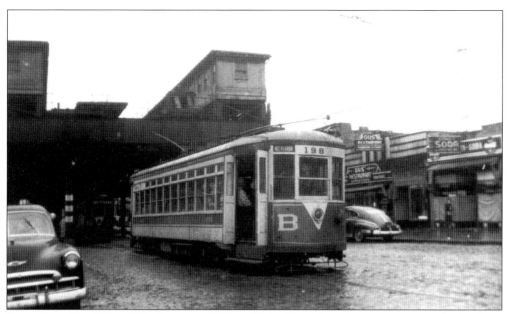

Route B car No. 198, at 241st Street and White Plains Road, boards passengers transferring from the IRT trains.

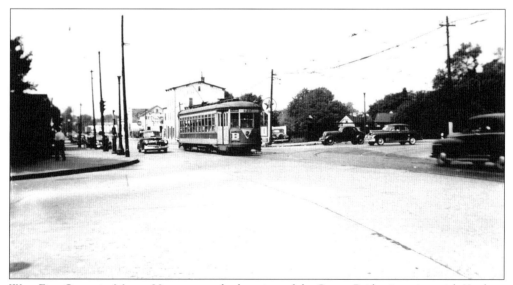

West First Street in Mount Vernon was the location of the Scotts Bridge junction with Yonkers Railroad cross-county Route No. 7. The bridge spanned the deep New Haven Railroad cut. Car No. 321 is en route to the end of the line at the New Haven Railroad station.

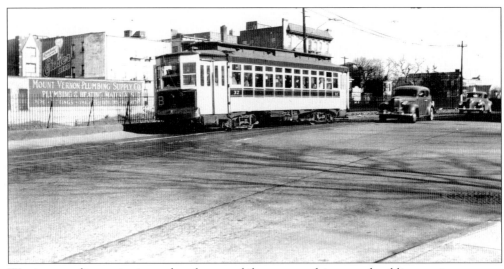

Wartime gasoline rationing reduced automobile usage and increased public transit passenger traffic. Older wooden cars were brought out of semi-retirement to augment the steel cars in handling heavy passenger loads. Here, car No. 32, already with many passengers aboard, receives more en route to the Bronx on West First Street at Scotts Bridge, Mount Vernon.

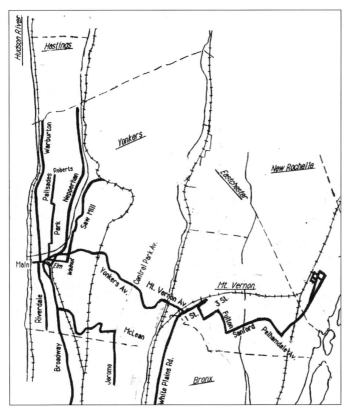

Shown here are the street car lines in southern Westchester County of the Yonkers Railroad and the Westchester Electric Railroad, subsidiaries of the Third Avenue Railway system, as of 1941.

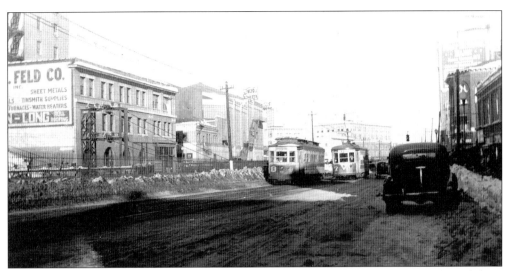

In this typical scene, westbound B-line car No. 46 passes steel car No. 331 eastbound from Yonkers on West First Street in Mount Vernon.

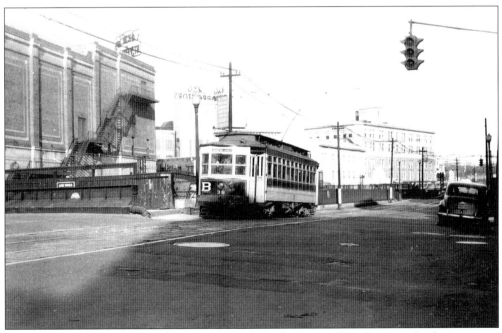

Wartime replacement convertible car No. 38 proceeds west on First Street at Sixth Avenue in Mount Vernon. The large building on the left is Loew's motion picture theater.

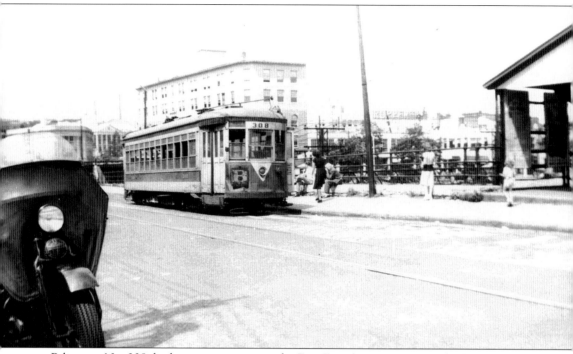

B-line car No. 308 discharges passengers at the East First Street terminus, which it shared with Yonkers cars. At the right is the entrance to New Haven Railroad's Mount Vernon station.

Five

CARS, BARNS, AND REPAIR SHOPS

All street railways required support facilities and work equipment to maintain reliable service. Car barns or depots were the bases of transportation services, where cars were dispatched, stored, cleaned, serviced, and repaired. Car operators, or motormen, reported to the depot dispatchers for their runs and assignments. Usually these operating locations were strategically located to minimize non-revenue runs, on- and off-car mileage, and the time between the barn and route. The Third Avenue Railway System had the following eight facilities:

Manhattan:
1. Third Avenue and Sixty-fifth Street—barn and main (central) repair shop.
2. 129th Street and Third Avenue—barn, paint shop, and general office.
3. Tenth Avenue and Fifty-fourth Street.
4. Amsterdam Avenue and 129th Street.

The Bronx:
5. Kingsbridge Depot, 218th Street and Broadway. West and central Bronx and some Manhattan cars were based here. The shop relocated here in 1947.
6. West Farms Depot, Boston Road near West Farms Square. East Bronx lines operated from here.

Yonkers:
7. Foot of Main Street, next to the New York Central Railroad. All Yonkers lines were based here. The shop was located here after 1948.

Mount Vernon:
8. Sanford Boulevard and Garden Avenue—barn and yard.

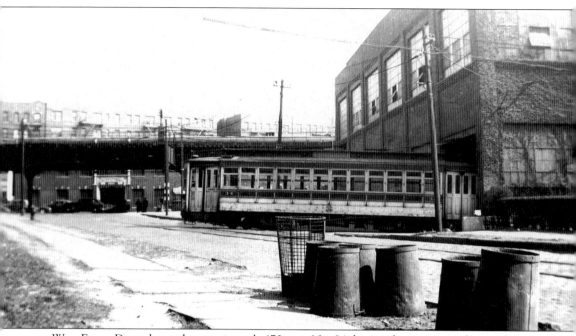

West Farms Depot housed approximately 170 cars. No. 34 departs for its run on the 138th Street Crosstown line.

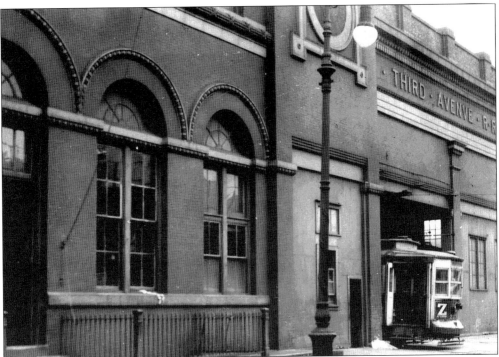

Kingsbridge Depot was a major facility. The two-story structure was equipped to power-conduit cars as well as cars with trolley poles. The lettering on the front reads "Third Avenue RR Co" and indicates a construction date of about 1900. The photograph on page 56 shows a line-up of cars on the depot's lower-level access track. Here, car No. 227 exits onto Broadway for service on the 180th Street Crosstown line.

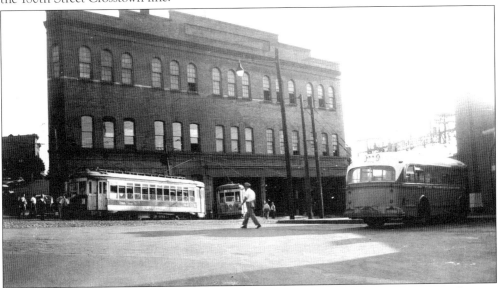

The Yonkers car house was the base for all Yonkers Railroad lines, housing over 60 cars. It was a major facility similar in construction to some Manhattan barns in that it had three levels for car storage with an elevator to move cars up from ground level. Transfer tables on each level moved cars from the elevator to storage tracks.

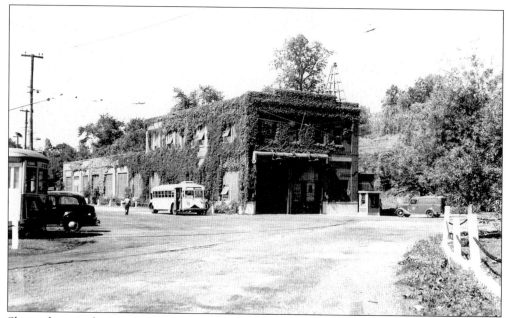

Shown here is the Mount Vernon car house and yard. This building was an inspection and repair shop plus storage space for some cars. It was the base for the two surviving Westchester Electric lines operating in New Rochelle–Pelham and Mount Vernon. Most of the cars were stored outside in the adjacent yard, where there was also an outside inspection pit.

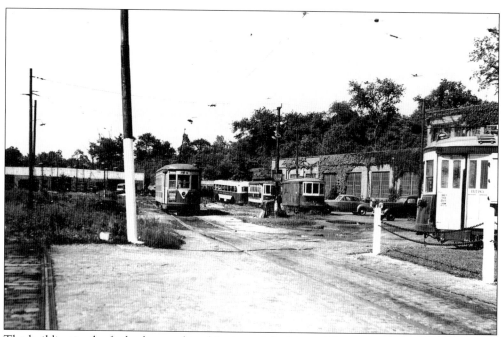

The building in the far background in this view of the Mount Vernon yard is a former car barn converted to motor bus storage and repair.

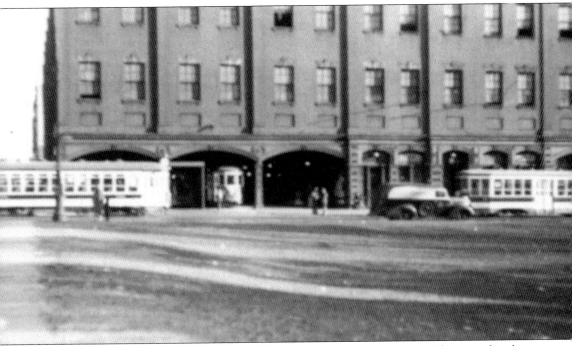

This multi-level barn was located at 129th Street and Amsterdam Avenue. This was also the northern terminus of Manhattan's Broadway line, and its cars were stored and serviced here. The building was equipped with an elevator and transfer table to move cars to and from storage.

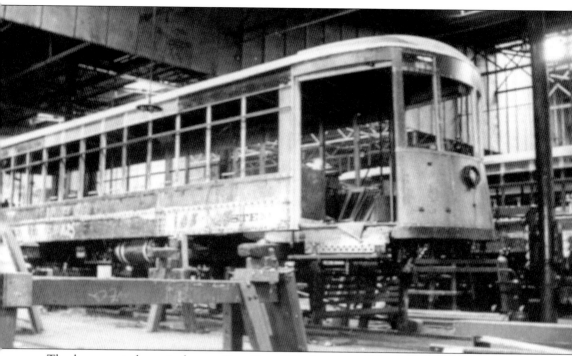

The large central repair shop at East Sixty-fifth Street and Third Avenue was also a major streetcar factory from 1934 to 1939, when the company was building its own cars. Here, a car is under construction in that shop in 1935. The company manufactured 261 of the front entrance with rear exit cars, and 75 of the front entrance with center exit cars.

Six

WORK AND
SERVICE CARS

In addition to passenger cars, street railways required a variety of work cars for everyday functions and for repairs or constructions of ways and structures. Types of work cars included snow sweepers or plows, sand cars, supply cars, rail grinders, dump cars, crane cars, flat cars, and unique to Manhattan and Washington, D.C., slot or conduit scrapers. The last type was especially outfitted for removing silt, snow, and ice from the underground conduit on the Manhattan trackage. Without removal, extraneous material would soon fill the conduit. Many street railway companies, including Third Avenue, converted retired passenger cars to work service.

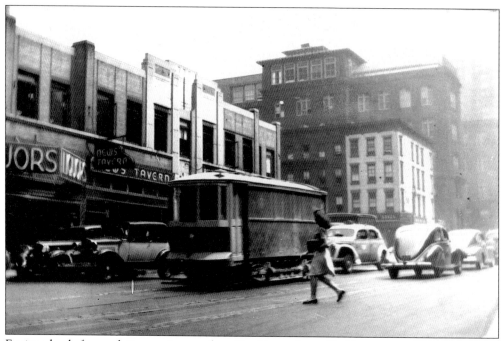

Equipped only for conduit operation, sand car No. 14 travels on 42nd Street east of Third Avenue.

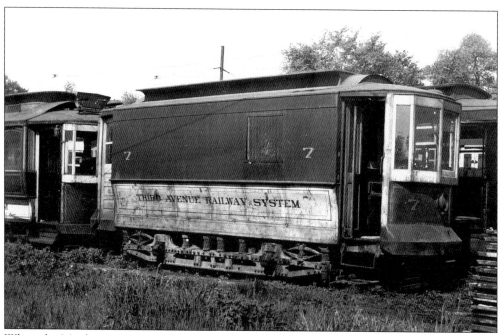

When the Manhattan streetcar lines were abandoned in 1947, the four car houses relinquished many ancient cars dating from the 1890s retained for work service. Seen here in the Mount Vernon yard, car No. 7 was originally a cable car that was later changed to electric operation. After retirement from passenger service, it was converted to a sand car.

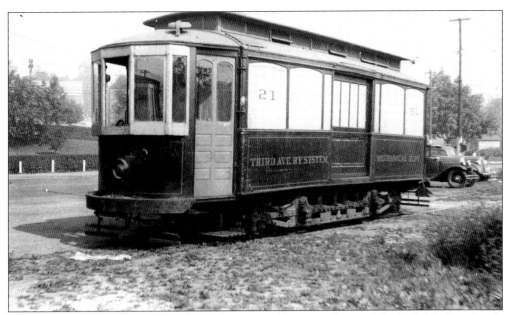

Shown in the Mount Vernon yard, No. 21 was a cable-car trailer used for U.S. Mail service. It was later converted to electric power and used by the maintenance department.

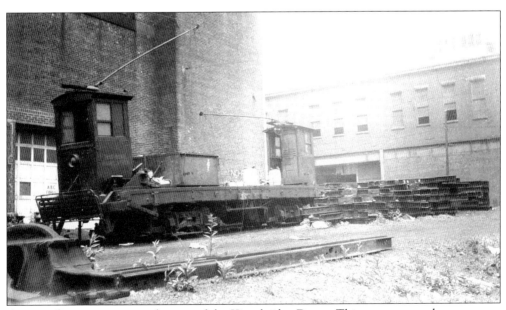

A motor flat car appears at the rear of the Kingsbridge Depot. This type was used to transport heavy items such as trucks, motors, and rails.

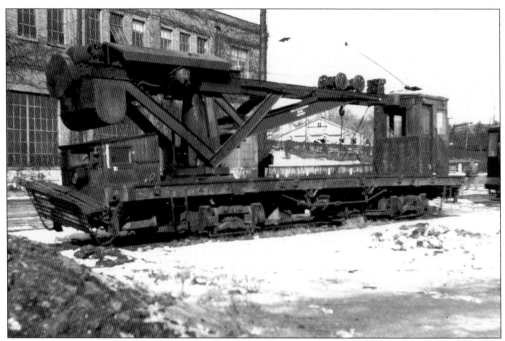

Crane cars were necessary to lift heavyweight materials such as rails and similar items. Shown in the Mount Vernon yard, No. 6 was acquired in the 1930s from the Connecticut Railway and Lighting Company.

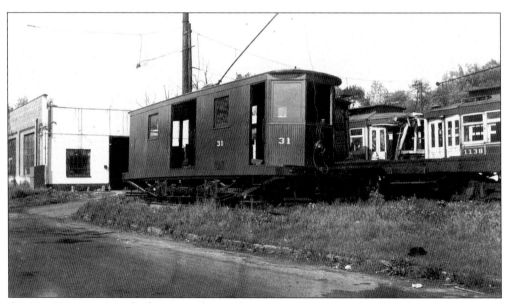

Car No. 31 was purpose-built as a conduit or slot scraper. It is pictured at the Mount Vernon yard prior to being scrapped.

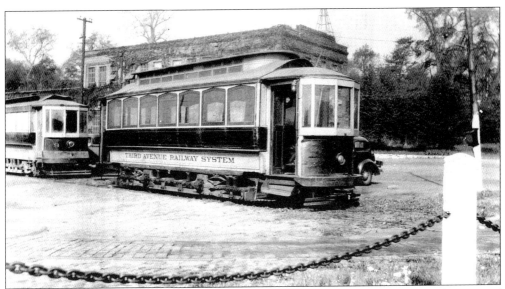

Shown in the Mount Vernon yard in front of sand car No. 9, car No. 32 was one of a group of unusual and ornate passenger cars built in 1893 as cable cars. The distinctive roof was known as a Bombay roof, an elaborate expression of car design from the period. It was converted to electric operation in 1898, and a few cars like No. 32 were later retained for service as slot scrapers. Because of its unaltered and unusual exterior appearance, one car of this type has been preserved at the Branford Electric Railway Museum in East Haven, Connecticut.

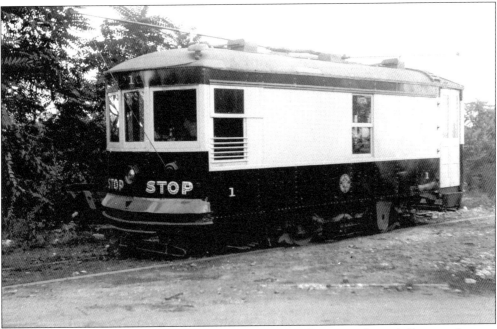

Work car No. 1, shown in the Mount Vernon yard, was a former single-truck Birney safety car. It was converted to a most useful purpose as a rail grinder to remove corrugations from the head of the rails. These corrugations created so much undesirable noise when a car moved along the rails that their removal was necessary.

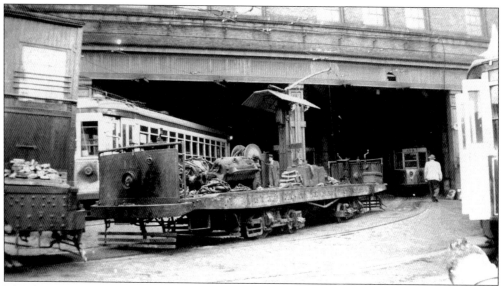

This motor flat car at the Yonkers car house was formerly an open summer car, now with its superstructure removed. Its function was to move heavy materials when required.

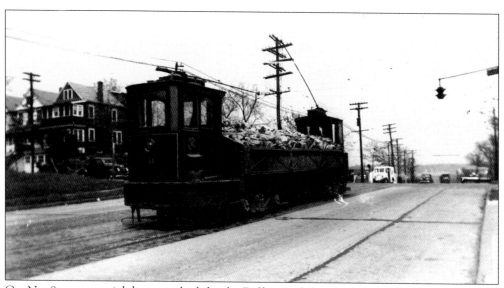

Car No. 8 was a special dump car built by the Differential Car Company of Findlay, Ohio, used for moving bulk materials. Third Avenue had a daily run where rubbish was hauled from various car houses to the Mount Vernon yard for dumping into a pit. The car is shown on Sanford Boulevard headed for that dump.

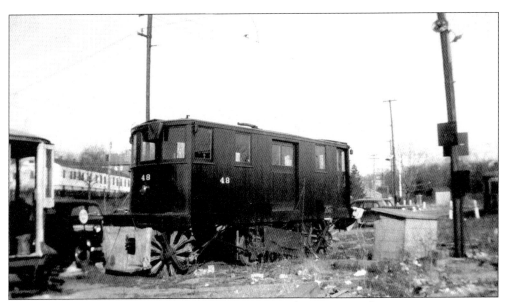

Snow is very unfriendly to streetcar operations. Special-purpose cars known as snow sweepers with revolving brooms were used to clear the tracks. Seen here is one of the special -purpose four-wheel cars in the Mount Vernon yard.

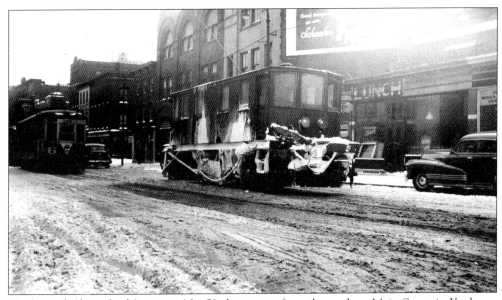

Single-truck (four wheels) sweeper No. 59 clears snow from the track on Main Street in Yonkers.

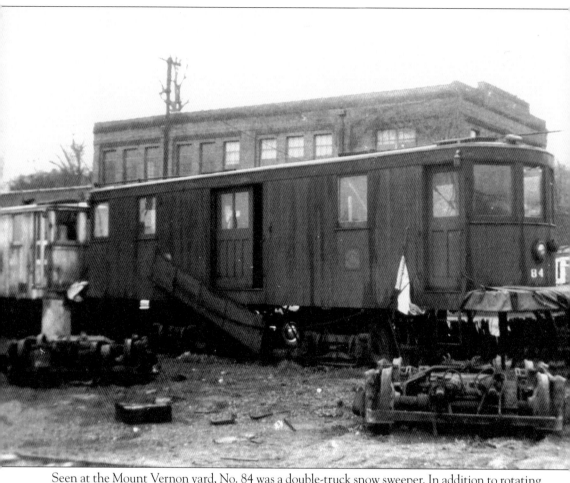

Seen at the Mount Vernon yard, No. 84 was a double-truck snow sweeper. In addition to rotating brooms, many sweepers had side-mounted blades for removing snow on the area adjacent to the track.

Seven

CAR RETIREMENT
AND SCRAPPING

When streetcars were retired from service due to replacement by new cars or buses, they were either sold for reuse or scrapped to salvage useful metals or parts. During the 1930s, the Third Avenue Railway built hundreds of new cars to replace obsolete wooden cars, which were scrapped for their iron and steel and other useful parts. During the car building program, retired cars were stripped and then scrapped. Long before enactment of environmental laws banned the practice, cars were burned to separate metal from combustible wooden parts. Third Avenue conducted its scrapping operations at Mount Vernon, where cars were burned. By 1946, there were still about 250 wooden passenger cars remaining in service in Manhattan and the Bronx. When the Manhattan and Bronx lines were converted to motor bus in 1947 and 1948, wholesale scrapping of wooden passenger and work cars commenced. Cars not equipped with trolley poles were towed to Mount Vernon, where the bodies were burned. The trucks and motors were disposed of separately because of the special steel and copper present.

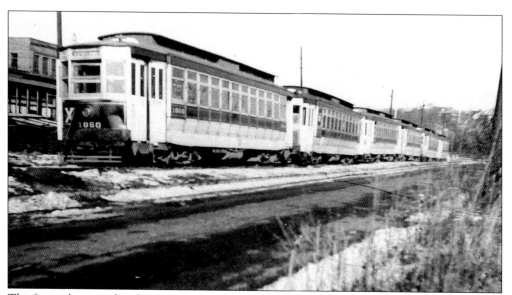

The first to be retired and scrapped were the former 42nd Street Crosstown curved-side wooden convertible cars. Here, six await their fate in the Mount Vernon yard. The good exterior appearance of the cars indicates the high quality of Third Avenue's equipment maintenance, even in those units nearing retirement.

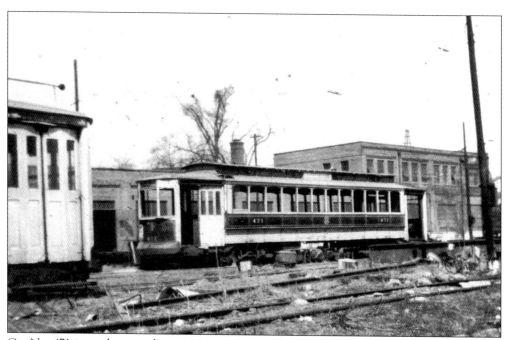

Car No. 471 is on the scrap line at Mount Vernon. It was one of a lot of 126 cars built in 1908 and acquired by Third Avenue in 1924 from New York Railways. By the end of 1942, all were scrapped except for the 20 sold to the San Diego Electric Railway in June 1942.

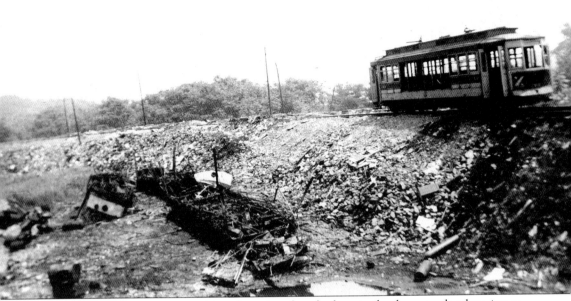

The final step in scrapping was pushing the stripped car body onto the dump track, where it was disconnected from the trucks. The car body was then toppled over into the pit and set on fire. The metal remains of previously burned cars are at the bottom of the pit. This car, No. 280, was built in 1911 and operated for 37 years, until 1948.

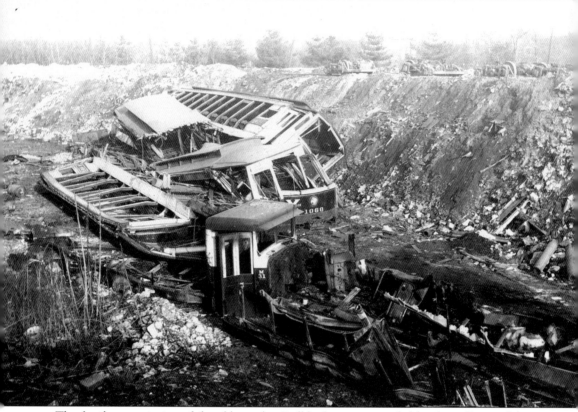

The fragile construction of the old wooden Brill-built cars is revealed by the collapse of the car bodies after being toppled into the pit. These bodies were set ablaze and the steel remains salvaged.

Eight

THE QUEENSBORO BRIDGE RAILWAY

The Queensboro Bridge Railway, an isolated 1.54-mile line, had the distinction of being the last streetcar line in the state of New York. It was a remnant of the Steinway Lines streetcar operation in Long Island City in the borough of Queens. Created by the Steinway Piano Company to provide local transportation for its employees, the system comprised several local routes plus the route that crossed the Queensboro Bridge to an underground terminal in Manhattan. In 1922, Steinway Lines went bankrupt and entered receivership. Herein began the relationship with the Third Avenue Railway Company.

Slaughter W. Huff, president of Third Avenue, was named receiver by the court to conduct the operation for the protection of the creditors. During the receivership, Third Avenue provided management services and rented equipment to Steinway, but at no time had a financial interest in the company. Steinway's equipment bore the same Steinway Lines name, but the coloring, striping, and lettering style were identical to Third Avenue's. In 1938, the creditors foreclosed on the property and decided to replace streetcars with buses except for the local line over the Queensboro Bridge. This railway segment survived because it provided the only public transportation to Welfare (Roosevelt) Island, located under the bridge in the East River. Stations on the bridge with elevators afforded access to the island for passengers coming from New York and Long Island City. By 1940, the bus lines and the bridge railway had been acquired by Queens-Nassau Transit, ending the Third Avenue management. Construction of a low-level bridge to the island made it possible to eliminate the car line in 1957.

In Long Island City, the bridge cars operated on the street under the elevated railway structure. Car No. 533 is bound for the end of the line at Queens Plaza. Equipment repairs on this isolated line were made at the New York underground terminal facility.

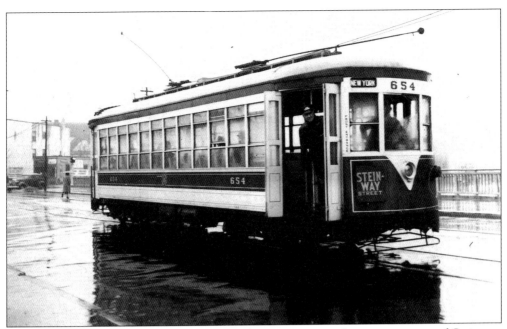

Pictured here is car No. 654. In 1939, near the termination of its management of Steinway, the Third Avenue Railway assigned one of its new cars to service on Steinway Street, pending completion of the overhaul of six cars to be retained for bridge service. The destination sign indicates the car is headed over the bridge to New York.

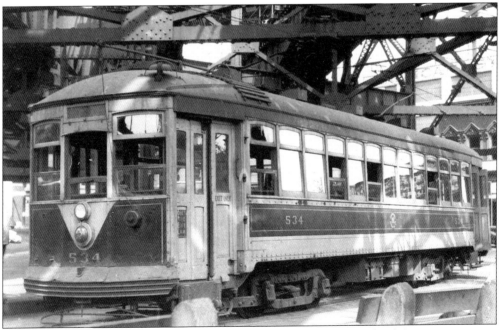

Bridge car No. 534 is shown at the terminus at Queens Plaza in Long Island City.

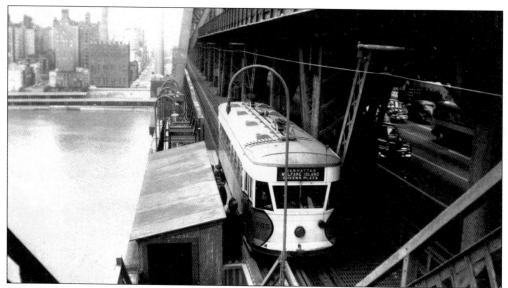

After 10 years of service on the bridge, the elderly 500-series cars were obsolescent and nearing retirement. In 1949, the line's operator, Queens-Nassau Transit, acquired six modern cars from the recently abandoned Union Street Railway of New Bedford, Massachusetts. They served the line until 1957. Here, No. 605 is stopped at the Welfare Island station on the bridge.

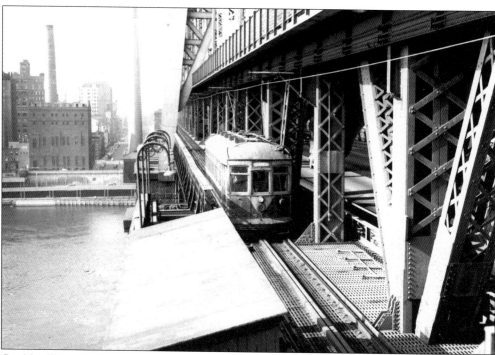

Car No. 533 is at one of the bridge stations. It was one of six cars overhauled for bridge service by the Third Railway car shop. (Courtesy Branford Electric Railway Association.)

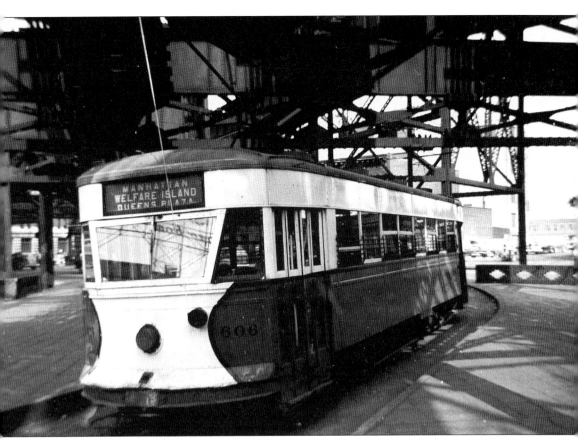

Former New Bedford car No. 606 is seen at the Queens Plaza terminal in Long Island City. The group of six modern cars served the line until 1957. (Courtesy Branford Electric Railway Association.)

Appendix

The Third Avenue streetcar lines operating in 1942 are shown with their line letter or number.

MANHATTAN

Broadway	B
Third and Amsterdam Avenues	T
Kingsbridge	K
Tenth Avenue	None
Forty-second Street Crosstown	X
Fifty-ninth Street Crosstown	X
125th Street Crosstown	X
Broadway and 145th Street	None

THE BRONX

Westchester Avenue	A
Boston Road	B
Bronx and Van Cortlandt Parks	C
St. Ann's Avenue	L
Ogden Avenue	O
Southern Boulevard	S
Sedgewick Avenue	S
Tremont Avenue	T
University Avenue	U
Soundview Avenue	V
Williamsbridge	V

Webster and White Plains Avenue	W
138th Street Crosstown	X
149th Street Crosstown	X
163rd Street Crosstown	X
167th Street Crosstown	X
180th Street Crosstown	Z
207th Street Crosstown	X

YONKERS RAILROAD

Broadway–Warburton Avenue	1
Broadway–Park Avenue	2
Broadway-Yonkers	3
McLean Avenue	4
Nepperhan Avenue	5
Saw Mill Road–Tuckahoe	6
Yonkers Avenue	7
Riverdale Avenue	8
Elm and Walnut Streets	9

WESTCHESTER ELECTRIC RAILROAD

New Rochelle–Subway	A
Mount Vernon–229th Street	B